Texas Death Row:

Reflections of a Different World

Texas Death Row:

Reflections of a Different World

Edited by:
Jennifer Gauntt, Julia Guthrie, Trina Kowis, H. Dave Lewis,
Shana Templeton, Robert Uren, Linda Wetzel

Texas Review Press
Huntsville, Texas

FIRST EDITION, 2010

Requests for permission to reproduce material from this work
should be sent to:

Permissions
Texas Review Press
English Department
Sam Houston State University
Huntsville, TX 77341-2146

The views expressed in articles published in this book are those
of the authors alone. They do not represent the views or opinions
of Texas Review Press or its staff, nor do they represent the views
or opinions of Sam Houston State University or any entity of, or
affiliated with, the university.

Cover art courtesy of David Lewis. Complete painting on 120;
commentary on 129.

Library of Congress Cataloging-in-Publication Data

Texas death row : reflections of a different world / edited by
Jennifer Gauntt ... [et al.]. -- 1st ed.
 p. cm.
 ISBN-13: 978-1-933896-51-9 (pbk. : alk. paper)
 ISBN-10: 1-933896-51-5 (pbk. : alk. paper)
 1. Death row inmates--Texas--Literary collections. 2. Prisoners'
writings, American--Texas. I. Gauntt, Jennifer.
 PS508.P7T49 2010
 818.6'0809206927--dc22
 2010032738

Publisher's Note

This book, the class project for my 2009 graduate Editing/Publishing Practicum, is a sequel to *Upon this Chessboad of Nights and Days: Voices from Texas Death Row*, which my 2008 class put together.

Students in these classes decide what sort of book they would like to publish, then solicit materials, evaluate them, assemble them into manuscripts, design a cover, and finally copyedit the book before it goes to the printer.

The first collection of work from Death Row was a resounding success, made possible largely by Greg Flakus, the Houston correspondent for Voice of America, who prepared an article (complete with video) on the book that appeared on television, radio, and the Internet throughout the world.

Since the class limited the literary selections in the first book to nonfiction prose, the 2009 class decided to solicit essays, short stories, poetry, and art for this sequel. In the first book we wanted to provide readers with an insight into the daily lives of these men: what they think and dream about, how they pass their time, how they handle the ever-present realization that each day that passes moves them one step closer to their date with the State. In this book we wanted to give them an opportunity to express themselves through other genres. In both we wanted to feature their art.

I am often asked why we do not include work from the ten (at last count) female inmates who have been given a death sentence. The answer is simple: Though we solicited work from them for both projects, we had no response at all.

This project is the culmination of a semester's work by my class: They collected the raw materials for the project, laid the book out, designed the cover, and did the final editing. If the reader finds typos or other editorial glitches, the fault it theirs: It was their baby all the way. (I would like to point out, though, that they elected to try to alter inmate submissions as little as possible, so there will be occasional lapses in grammar. Furthermore, transcribing from hand-written submissions is always likely to engender errors.)

—Paul Ruffin

Introduction

In 2008, students in the graduate editing/publishing course at Sam Houston State University compiled nonfiction prose and artwork for the book *Upon this Chessboard of Nights and Days: Voices from Texas Death Row*. The purpose of the collection was not to take one side or the other in the ongoing debate over capital punishment, but to offer a forum for the ideas and experiences of the least-heard participants in that debate. Regardless of personal ideologies, the editors and, eventually, the readers of *Voices from Texas Death Row* gained access to essays about life outside and inside of prison, declarations of innocence, and admissions of guilt. The book is a look inside a place whose name is more familiar than its nature.

When our class gathered this fall, we knew we would assemble another collection of material from Death Row. We had at least two reasons: One, we thought the insight to be gained into our society and into the human experience could be deepened with the inclusion of inmates' creative expressions; so we solicited fiction and poetry and especially encouraged the submission of visual art, which had enhanced the first book. Two, we realized that this sort of project is always urgent. The night we drafted this introduction, Bobby Wayne Woods was lethally injected at the Walls Unit near our campus, the twenty-fourth execution in Texas in 2009. Woods isn't featured in this book or its predecessor, but two of those twenty-four are. Derrick Johnson and Danielle Simpson have each been executed since their contributions to *Voices from Texas Death Row*. Whatever is to be learned and whatever talent is to be shared from Death Row, now is the time for it to be learned and shared.

To that end, we offer you *Texas Death Row: Reflections of Another World*. In these pages, you will find essays about injustice and angels, poems about family and God, letters to loved ones, and a story about a puppy, along with proficient drawings, detailed paintings, and cartoons. Together, the pieces provide a glimpse into the lives of the inmates on America's most active, most mythologized Death Row.

While putting this book together, we were struck by a number of things. First, the artwork is stunning, especially when one considers the creativity required to gather materials, let alone to use them so skillfully in an environment so alien to aesthetics. Second, the writings

are diverse, as are the men behind them. And third, the collection transcends the controversy. After four months together, we realized that we had not once discussed our individual views on the death penalty. That, of course, wasn't our purpose. Our purpose was to coordinate the book you now hold, to make its variety and substance available to you.

In that effort, we were aided by many people. To the writers and artists who responded to our requests with these and other snippets of their lives, we are grateful. We hope the exchange has been mutually nutritive. Our correspondence with those inmates would not have been possible without the Texas Department of Criminal Justice, whom we thank for their cooperation. The publicity received by the first book, especially from Voice of America's Greg Flakus, helped make this book possible. We appreciate Greg and the many other people who have furthered the cause of both books. As students, we owe much of our success as editors and bookmakers to our professor, Dr. Paul Ruffin. And, finally, we thank you, the reader, for taking the time to embrace this collection of entertaining, compelling, sometimes difficult and often surprising works from the inmates of Texas Death Row.

—Texas Review Press staff

Table of Contents

Art from the Row

Texas Death Row:

Reflections of a Different World

Danny Paul Bible
#99'9455

Oceans of Violations

Black inky fingers of darkness
Descend and rape the alone
The declining masses lie wasted
In heaps across the pillaged land

Tentacles of hypocrisy abound
Tasting the blood of the innocent
Enslaving the powerless ones
Murdering all who oppose them
In the name of Justice or Just-us

Casting about to and fro
Their soulless smiles seeking
Only those totally left alone
While the huddled masses
turn deaf ears to their screams

Tortured cries rise futilely
Seeking in their pleas—justice
Met with only indifference and silence
While the masses smile with relief
And the Darkness passes them by

But the silencing of the lambs
Roars out the questions as a flood
Across the neutered despoiled land

When will you listen to our pleas?
When will you see our murdered deaths?
When it finally happens to you?
Innocent blood is on the land

And on your blinded, deaf hands
See and know before it's too late
Once darkness descend's on you
You will know the same fate
Hear me now in one voice
Of all who have gone on before me
　　　Said

What good are my rights when all those that advocate them
don't hear or care about the rights of just the one?
How many have you turned a deaf ear to because they are
just the power of only the one? Is there not enough of them
to make an ocean?

So the question still remains, what good are you, if even one
person's, rights have been violated, and you do nothing what-
soever
to defend them? Isn't this just as much a violation when only
the one cannot be heard?

Eugene Broxton
#999044

In My Thoughts

I couldn't see you today.
So I sent you my thoughts!
Living and vibrant they speed through
the air, out through the other, through
miles and through time.

I hope you received them and knew I was
there. I couldn't see you today
So I sent you my love.
It travelled through space like a bright
shooting star!
With the joy of the morning, the warmth
of the sun.
To wrap itself around you, wherever you are.
I couldn't see you today, so I sent out
a prayer, for I knew you were troubled,
and heavy of heart. And so with my
thoughts, my love and my prayers,
Though distance divides us, we're
never apart.
Keep faith and hope within your heart
though trials come your way, we all
must face them sometimes. It could
be now, today
Just do your best and carry on,
for what will be, will be,
And with friends to help you
You'll stay on course, you'll see.

The Art of Friendship

Being a good friend is really an art.
It's a wonderful talent that comes
from the heart.
It's knowing the kind things to do
and to say.
Like listening and talking a problem away.
It's laughing and sharing and being together
in bad times, glad times, in all kinds
of weather.
Yes, being a good friend is really an
art, it's a talent that comes from a
kind loving heart.
It's really nice to know that
I found a good friend in you.

What Can I Give?

What can I give in return for
All that you have given to me?
You have given me love and support
like no other human being.
My life is richer because of you.
I often smile when I think of you.
I've even cried tears but not of
sadness.
You have touched my heart and
filled it with gladness.
I thank God above for sending
You into my life.
But what can I give in return to you?
I feel I owe you my life.
In the few years I've known you
You have shown me more love than
I've ever known in my life.
But what can I give in return
to show that I love you?

I Just Can't Imagine

I just can't imagine a life without love.
A day without you.
No moon up above.
I just can't imagine a sky without blue.
A night without stars
Or a life without you.
My life would lose meanings without
your caress.
You mean more to me than you ever
could guess.
You're everything good, so loving
and true.
I just can't imagine a me without
you.

Reinaldo Dennes
#999248

Fifty-Five

A rainbow within is what I see.
A life beyond is what I seek.
A pot of gold I have found.
To share with all I am bound.

It's bright and twinkles as you smile and look.
Be not afraid, love, there are no hooks.
Take a piece to your heart and pray.
You will find that love and peace are not far away.

Shut your ears and you will hear.
Close your eyes, and do not cry
For life is eternal, if you believe.
Have faith love and you will see.

I am content living in this tent.
Even if one day I paint no more.
Still in my heart love is sent
For my Savior lives forever more.

You say, "You are not blue."
I think not your words are true.
For how can you be in that place.
And say I am full of grace.

It's the love I've found
That keeps me sound.
It's the music between the notes I hear
Love sings to my heart so dear.

My time has come, my words are done.

I am not alone, nor am I my bones.
At fifty-five I will fly.
For the version I cannot deny.

"Te quiero mami linda."

Cleve Foster
999470

The Little Jacket—"Don't Get Cold Daddy"

In the first Texas Death Row book, many spoke of their children and as I read, my own child often came to mind. His name is Michael and was born in Carlsbad, N.M., and from the day he took his first breath my love for him has never faltered. "I love you Son." Growing up, my son has always been a big hearted kid, big smiles and always had a hug for anyone.

Michael was three when I was called up for duty for Desert Shield/Desert Storm. I remember it well. My son was asleep on my chest as he had done many times and when the phone rang the voice said, "Is this Staff Sargent Foster?" YES! and then all I heard was "ATTENTION TO ORDERS!"

I kissed my son on his head and put him in his bed and packed my bag, all the while giving my wife all the info she was going to be needing while I was gone. Well, during all the packing I had mentioned how cold it would be at night even in the desert so I should pack some extra, so I did and went on.

Once at the airport we were saying our goodbyes and as I took off down the terminal my 3-year-old son came running, "Daddy! Daddy! WAIT! WAIT!" I turned and gave him a hug and told him, "I've got ta go son," but with tears in his little eyes he handed me his little camo jacket and told me "Daddy I don't want you to get cold." (Talk about fighting back tears). "Saubee Alt Wabia is cold," he tells me. I took his little camo jacket and stuffed it inside my jacket and held on as his mom peeled him off me. My little man.

To this day that little jacket is with all my gear, back home in Kentucky and should anything ever happen to me, everyone knows that all my military things will go to my son. Even the lil' jacket.

OP Brite Star, OP Joint Endeavor, OP Rifles ove, everyone would always ask me about "that little jacket" and always I took a few minutes to tell them about it, and like always, they would smile and move on. I love you, son.

Angels on Earth, Y'all!

Who really knows what an angel is? And for the record, can any one tell me where they came from? Well, let me tell ya, folks, from my perspective, I'm sure they came from heaven and at one time were God's sidekicks. So why would they wanna come to earth and give up them wings? Hmmmm.

Don't know! But I will say this, I have met a few.

I'll only use their first names and I'm sure as I'm speakin of them you'll say to yourself, "Hey! Reflect a bit," then ask yourself, "Has an angel been in my life?"

Margaret became a friend of the family back in the 70's, an officer of the Salvation Army and just as cute as a button. My folks divorced when I was young and at the time there were four of us children and back then the courts were not as strict on child support as they are today.

BAM! $40.00 Yup! Forty bucks was all the child support my dad had to pay each month and let me tell ya, if you've never had to feed four growing kids let me let you in on a lil secret—$40.00 was not gonna do it.

All of us kids knew Margaret from church but one thing we didn't know at the time was the struggle my mom was going through to raise us, work and 4 kids was really tough so needless to say we were delighted to come home one day to see Margaret. Well, mom came home from work and told us that Margaret would be helping out around the house. Cool! Cooking, homework, and even making sure we washed behind the ears; she loved us as her own. She loved us enough to stick around through all the Hell and pains of raising kids and Lord knows how she made it through our teen years. Ha Ha. She dug her lil feet in and held the fort down though and after having heard some of the stories from the guys in

here, I thank God for sending Margaret to us.

Then just after arriving on D/R I got to meet a couple more.

My first week on D/R my neighbor came back from a visit and spoke of who had come to see him and mentioned her name. "I know her," I said. "Yeah Right! New boot! You just got here so there's no way." Well, a couple weeks later he was called for a visit again so I asked him to ask her if she in fact knew a few people and if she does tell her, I know her! Well, he came back and sure enough she knew the names I'd mentioned and from that day Kathryn has visited me. She's talked me through many tough times and has without a doubt helped keep me sane.

Kathryn is a retired Salvation Army major and on the backside of her 80's but to see the way she gets around you'd think she's not a day over 60. She visits over 25 other inmates and has been spiritual adviser to about 100 inmates and has sat next to the gurney as those 100 (just estimating) fell under the needle and went on to the after life.

Like Kathryn another lady (Angel) whom almost everyone on D/R knows, Irene makes the trip to D/R 5 days a week and she too has sat by many at the death chamber.

I don't know how they do it and still remain sane. So in my book Kathryn and Irene who are known by so many will forever be Angels.

Ladies, I thank God for you all and after reflecting on it all, I think I know why you gave up your wings, because you're angels. ♥ U 2

III

For the last few days I've heard other inmates laughing saying, "Yo, Sarge! You're crazy man, your spider story is funny as hell," and many others have told me they were touched by the story about my mom being my hero. To all you men I say, "Thank you!"

Mr. Ruffin, you're 100% correct, I believe people in the real world should know more of the people on death row and how they get there and a little of who they really are. Lord knows, the state has done their job in painting its version of us.

Mr. Ruffin, I'd like to say another thing, many people in the real world have been misled into thinking that, when some inmates claim they're innocent, what some are trying to say is, they are not guilty of capital murder. What I've learned from my time behind bars is, many of the ones guilty of murder will look you in the face and say, "Hell yeah! I'm guilty of murder" but it was the overzealous prosecutors with political careers in mind who slapped the capital to it.

People in the real world get a hard on when election time comes, and when the people who are running for election mention how they put someone on death row, then the horns really start to show. Oh, and if you think I'm full of shit, show me one election where someone has not mentioned D/R. Yup! Just another step in someone's political career. Elections are open doors to corruption. Most of the people on death row are here due to the fact drugs had a play in it in some way and now that drugs are no longer in the picture, most are not as they were in the real world.

I've heard it said that it takes 2-3 million to execute a person. Wow! I wonder how much it would take to stop the drugs? Hmmm. What's Texas spent in the past 10 years on executions? Over 300 million!

Killing is wrong no matter who does it, so why not spend our money on what causes the people to kill.

My heart goes out to all victims and I pray someday you all can learn to forgive. God bless you all.

Bill Gates
#999376

Praise God from whom all blessings flow Praise Him all creatures here below Praise Him above ye heavenly host Praise father, Son & Holy Spirit My country tis of thee Sweet land of liberty of thee I sing land where my fathers died land of the Pilgrims pride from ev'ry mountainside Let Freedom ring My native country thee land of the noble free Thy name I Love I Love thy rocks and rills Thy woods & templed hills My heart with rapture thrills like that above let music swell the breeze & ring from all the trees Sweet freedom's song let mortal tongues awake Let all that breathe partake let rocks their silence break The sound prolong Our fathers God to thee Author of liberty To Thee we sing long may our land be bright with freedoms holy light Protect us by Thy might Great God our King. Our father shall not make no images of other Gods You shall not no other Gods You shall not bow down to no other Gods or serve them. Love me & keep My Commandment You shall not take the lord God name in vain Observe Sunday as the Sabbath Holy day keep it holy all ways honor your parents as God has commanded it You shall not murder You shall not commit adultery You shall not steal & you shall not bear false witness. You shall not covet your neighbor's wife or anything that is your neighbor's Our father in heaven Hallowed be Your name Your kingdom come your will be done On earth as it is in heaven Give us day by day our daily bread And forgive us our sins for we also forgive everyone who is indebted to us And do not lead us into temptation But deliver us from the evil one The Lord is my shepherd I shall not want He makes me to lie down in green pastures He leads me beside the still waters. He restores my soul He leads me in the paths of righteousness for His name's sake Yea though I walk through the Valley of the shadow of death I will fear no evil for you are with me. Your rod & Your staff they comfort me. You prepare a table before me in the presence of my enemies You anoint my head with oil My cup runs over Surely goodness & mercy shall follow me all the day of my life & I will dwell in the house of the lord

God forever. Now faith is the substance of things hoped for the evidence of things not seen for by it the elders obtained a good testimony by faith we understand that the world were framed by the word of God so that the things which are seen were not made of things which are visible Finally my brethren be strong in the Lord God & in the power of His might Put on the whole armor of God that you may be able to stand against the wiles of the devil For we do not wrestle against flesh & blood but against principalities against Powers, against the rulers of the darkness of this age against spiritual hosts of wickedness in the heavenly place. Therefore take up the whole armor of God that you may be able to withstand in the evil day & having done all to stand. Stand therefore having girded your waist with truth having put on the breastplate of righteousness & having shod your feet with the preparation of the gospel of Peace above all talking the shield of faith with which you will be able to quench all the fiery dark of the wicked one And take the helmet of Salvation and the sword of the Spirit which is the word of God praying always with all prayer & supplication in the Spirit being watchful to this end with all perseverance & supplication for all the saints & for me that utterance may be given to me that I may open my mouth boldly to make known the mystery of the gospel for which I am an ambassador in chains that in it I may speak boldly as I ought to speak

For judgment is without mercy to the one who has shown no mercy Mercy triumphs over judgment. Let him know that he who turns a sinner from the error of his ways will save a soul

Ronald James Hamilton
#999436

Soul on Fire!

My eyes were blind to the life I lived but my soul could see the pain I would have to endure. With all the sex, money, and street fame; it was hard to feel the heat of the flame. My mind was running and playing like life was a game. Not knowing that my heart in a short time will feel so much pain. This pain can't be seen with the eyes or heard with ears we have. But it was there in my pain that my soul caught fire not the fire we used to cook our food nor the heat we use the keep us warm. But the fire of God Himself, yes the "Holy Spirit" . . . When I was all alone that was when the pain was its strongest and I could feel nothing else. I would call on the people I love but they couldn't help me. Every day I looked for sunshine but found nothing but rain. So I called on the one I heard could take away all my pain, "Jesus." And with the calling of his name I felt His love and it stopped all the pain. That was the day my soul caught fire!!!

"I Have Changed"

The thing that matters more than the mistakes we make; Or what we learn from thee!!

David Lewis
#000866

If you could see life through my eyes,
you'd see the need for my disguise,
for who I am I hold within.
Holding my thoughts behind this grin for time has ways
to make you strong when you are not where you
belong. All people know is what they are told,
makes them believe my heart is cold,
with time I pay for my mistake.
As they all try my will to break,
but inside of me are walls of my own.
Harder than brick or even stone,
they're part of a home that's waiting to be complete once
again.

<div align="center">On accompanying picture</div>

This is what you call true prison art. Back when inmates could
write each other you would get an envelope from your buddy
that looked like this. It was awesome to get a letter from your
friend and the envelope was decked out like this. You would
have to be a prisoner to truly understand the meaning of
drawing. There is *no* gang stuff and it isn't satanic. When you
got an envelope like this from your buddy it was a challenge
to outdo him on the return letter. Since we can't write each
other anymore and we can't draw on envelopes you don't see
this kind of art anymore, only a few still keep it alive and I'm
proud to say that I am one of them.

 I started with one brick and just let my mind wander. I
know that it's no fuzzy dog or pretty flowers but it's still art,
real prison art.

Joshua Maxwell
#999408

The Prodigal Son

Sitting here contemplating my future while the state
contemplates my fate
Threw me into this cage years ago & forced me to endure the
wait!!

To anticipate their next move, while I calculated mine
(Y?) in time, I've gathered all of the courage I could find!!

Now I'm ready for this stage, steady my aim, fire & release my rage
I close my eyes, while my pen scrolls across this page!!

Speaking from the soul, because I want you all to know, what's
within
& that these aren't words aimlessly being put together by a
brainiac with a pen!!

These words are mine & my thoughts are genuinely depicted
in each & every line
Despite casualities, I'd like to say that I'm fine, although the
torture & time has most definitely distorted my mind!!

Through this little hole they call a window, the sun does shine
to me that's a sign
I'm ready to give it my all & why not, my life is on the line?!

The soul of a warrior, yet insecurities of a man. As we all
know, it's not in comfort, but adversity when we know where
you stand, & here I am!!

Scared to death inside, trying not to cry, not wanting to die,
while doing my best not to show it

Ironic, wouldn't you agree that it's taken all this for me to articulate the heart of a poet!!
I've questioned that heart, my soul, my mind & intent
I've questioned God, life & the purpose for this world I was sent!!

I repent, & never meant to hit the ground running, hell bound for life I've held down!!

Celled down like a beast, no peace
& you legalized killers are the ones, who expect the maddess to cease?! PLEASE!!

Ask yourself, was he an animal, before he was treated like one?!
A man, not an animal in a cage
here I come,
The Prodigal Son!!

Tony Medina
#999204

Know Yourself

Can You
Honestly
Look At Yourself
And See
What Can Not Be Seen?

Can You Look
Within
Your Heart
And Know
Your True Self?

Can You See
Through Others' Eyes
What They See
In Yours?

Can You
Know
Without A Doubt
The Depths Of Your Love?

Until You
Have Conqured This
You Will Never
Know Yourself?

Until You Know
Who You Are
Do Not
Attempt To Judge

Me?
And Since You
Have Not Faced
All I Have
Do Not Say
You Know
Me.

I Need You

I need you
 once again in my life
to help steer me right
 when I start to slip
to hold me close
 when the emptiness becomes too much.

I need you
 to balance the scales
to remind me always
 of how good things can be
to show me I can still feel
 the same as others do.

I need you
 to keep me sane
to whisper in my ear
 like you use to do
to show me I am not alone
 in this journey called life.

Rodolfo Medrano
#999501

Fear

According to *Merriam-Webster's Collegiate Dictionary*, fear is an unpleasant often strong emotion caused by anticipation or awareness of danger; anxious concern; and a profound fear, respect and awe especially toward God. Fear and respect toward God are becoming less and less visible among us. Death Row is evidence of this lack of fear, and our past and present lives prove if we have learned to fear God.

Our lives before Death Row were full of lying, stealing, dealing, coveting, robbing, cheating, hating, fighting, killing, pride, arrogance, evil, cursing, drugs, alcohol and women without fear of consequence or God's hatred of such things. Many of these evil ways were limited by sending us to Death Row, but their consequences remain. Most of us heard about God, but never feared His threats of judgement and punishment against our evil and sinful ways. No fear of God has shortened our days and separated us from family.

Our lives on Death Row prove if we have come to our senses in fear of God. We should look back and hopefully recognize how living our own way has rewarded us with a death sentence, as God forewarned. We should reconsider our way of thinking and living because it is obvious that we were completely wrong before. Is it wise to continue down the same path of sin and self-destruction that led us here? Is it not better to get the right directions on how to live what is left of our lives and prepare for our appointment with God? We must humble ourselves before God, admit we were wrong and foolish, and live life as God has spoken through Jesus. We must fear God or seal our fates. Our way of living reveals our choice.

Let us hear the conclusion of the whole matter: Fear God, and believe in Jesus: for this is the whole duty of man. For God shall bring every work into judgment, with every secret thing, whether it be good or evil. We are so close to our final judgment, where no appeals are available and where no appointment can be rescheduled. Your choice will determine your state after death. Fear not them which kill the body, but are not able to kill the soul: but rather fear God which is able to destroy both soul and body in hell.

Ronnie Joe Neal
#999510

Who Am I?

WHO AM I?

I am the last king on the throne. Everyone else has come and gone but me. . . I'm still killing strong. . . 25 million and counting. I can stand right before you and you still not know it's me. Do you still think unprotected sex and sharing needles can't cause your death? You're crazy! You must be suicidal, I've been on American Idol. . . .

WHO AM I?

I have a face like Beyoncé, eyes like Angelina Jolie, and you'll never recongize me. Why battle the odds? You know there is an 85% chance you could lose your life. If you step on my field, you play my game, having uprotected sex or sharing needles you lose. That is a bad choice to choose. It only takes one time having sex without a condom, or one time to share a needle. . . .

WHO AM I?

You can walk away from here and let this go in one ear and out the other one. I won't be feeling sorry for you. You had a chance and by your choices, along with your ignorance you chose to die. . . .

WHO AM I?

Do you think a few minutes of uprotected sex or a hit of dope is worth your precious life? I don't think so. I can hide behind your body because you can't see me. Anybody could be me. I change victims like a chameleon changes colors. I have only one mission and that is to destroy your body. If you think I'm trying to run game instead of trying to save your life Go ahead and push PLAY and let the games begin. I know the outcome already. You are going to lose. . . I'm going to win

WHO AM I?

I'm the only person that walks through airport security undetected, while the world suffers from my infection. You thought you were a player, but you just got played. So what. . . You got laid! The price has been paid. I have made more than 25 million graves. Unprotected sex and sharing needles can kill you, and the world cannot stop me or I wouldn't be here. . .

WHO AM I?

I want you to keep not telling your kids about sharing needles and unprotected sex. I will keep adding their deaths to my list! Once I'm in your blood, it's 'til death do us part. I play no games and am telling no lies. . . Unprotected sex and sharing needles could cause you to die. I'm so clever that I have created an army with people worldwide. There isn't a place I can't be. There isn't a persona I can't be.
So. . . You can't even hide

WHO AM I?

One in a Million You

Girl, I'm so into you. There's nobody else like you. You're such a blessing to me . . . In my whole life: You're my definition of paradise.

Sometimes finding true love takes time. Some people go through life without ever enjoying the true fulfillment of REAL LOVE. I never thought my heart would love like this. You've expanded the depths of my soul . . . My loving you is beyond my control. If I died right now, I'd die loving you.

I feel so complete. I can't describe what all your love is doing to me. There are times I don't know what to do. You have quenched my aching heart's thirst. It's not the things you do that makes me love you. It's just you being you that allows me to see and know that what we share is so profoundly true.

Nobody can ever take your place in my heart, forever shall it remain your home. The look in your eyes as they look into mine; the word "sensation" would be an understatement. You give the word new meaning.

To find love . . . two broken hearts destined to find love . . . we found each other. God has his own way of answering prayer. I am the prayer you prayed. Let my love cater to your heart's needs. Allow it to experience the exquisite taste of love so true, divine, amazing

The love I have for you has no end. Out of the billions of people in this world . . . God chose ME & YOU to fulfill this quest called love. Can't you see? It had to be me . . . It had to be you . . . ONE IN A MILLION YOU

I love you, Audrey

The Letter That Saved My Life

Dear World . . . I was Sentenced to die May 2, 2006. I was later transported to Texas Death-Row where I was assigned to cage Number 12-AF-73. As I sat alone in that cell, I started to think my life was over. I already had HIV and adamantly refused any and all medication. In my mind I wanted to die. While I was growing up in San Antonio my mom constantly told me about God, but I never wanted to hear that there could ever be a God. By the time I got to Death Row I knew no one loved me but my family. I tried suicide April 4th, 2006. I just knew I took enough medicine to die, but God refused to let me die. September 9th of that same year I received a letter with my name and number on it. At first I threw it in the trash because I didn't want to be involved in any prison romance. My next door neighbor asked me if I received any mail? I said "Yes . . . but I threw it in the trash!" He told me, "Man you should open and read it because it might be some one who wants to help you!" It took me a few minutes but finally I opened it. The address inside showed it was from Scotland . . . A place I never heard or knew existed . . . from a woman named Audrey Fitzgibbon. It was dated September 3rd 5:15 pm. She stated in this letter that she had been looking for someone to write for the longest. Somehow her original letter to Human Writes got lost and the category she falls under, since she lives in Scotland, is supposed to be for North Carolina, but somehow, (perhaps it was a miracle) she got my name and number. She told me in this letter she wrote to me that for some reason she believed we were meant to be pen pals. I thought she was crazy and I didn't know how to respond to that. We began to write each other and grew to be friends and then so much more. Being from the streets, I never knew what love was. I was abused as a child and still carry those scars; some you can see, others I carry on the inside. Those are the ones hardest to bear . . . I found out her dad abused her, too, so we had a lot in common. I have always been afraid to trust anyone but my sister, Debra Neil. Meeting Audrey I felt real love for the first time. We introduced love to each other

and she opened up the flood gates of my heart. I had been planning to committ suicide January 18, 2007 on my birthday and had saved up enough medicine to do the job. Death Row officers do not make rounds that often. . . . At least not as often as they are supposed to, so I knew I was going to die. However, as I began to write this beautiful amazing woman I began to open up to her. Yet her winning my trust still wasn't going to be easy. My being from the streets, I was taught to never trust any woman and especially not to fall weak to them. We continued to grow into something I had never ever experienced in my life. I began to fall in love! This amazing love inspired me to open up my heart and my thoughts. Soon I began to write love poems revealing what I was really feeling in my heart. Here I am on Death Row . . . in love . . . feeling something I never ever knew possible for me to feel. This love changed everything, my whole outlook on life, and made me want to be a better man . . . a better person. I became more compassionate for life as our love grew deeper, but we still had a problem: she was married! I didn't let that stop me. All the guys call me crazy for spending all my money on her, spoiling her with drawings and things but what they never understood is that it was not all about me anymore it was now about *us*. I vowed to my homeboy Kevin Watts who was executed October 16, 2008 that I was going to win and make this my wife because her husband never loved her like I did. I even sold my radio to be able to send her a drawing. People could not understand it, but I do because I know she is my music, my song, the melody of my heart, the harmony of my soul, the rhythm that gives my life meaning. I love her even more today. I told her about being HIV positive and that even brought *us* closer. I worried that telling her could end our relationship, but it made *us* that much stronger. It has inspired me to come up with some serious awareness I think the world should know. I call it. "WHO AM (eye with ?) because people think they can recognize and see the virus. I am 270 pounds; I was 270 pounds without medicine. If I never tell you I have the HIV/AIDS virus there is no way for you to know. People in the world think you can see it, but you can't. Audrey inspired me to come up with the logo . . . "An eye with the question mark in

it." She had never been to the United States before she came to see me. She made that journey for me and met my family. They embraced Audrey as one of the family. They love her and are all still very close to this day. Despite some ups and downs we still love each other. More than ever I never ever have felt anything so wonderful like this in my life. It was her love that motivated and changed my life. She means the world to me. She's my reason for living. I'll forever be grateful to her, for it was her letter that saved my life.

My Angel

I don't know where you came from, but my life is glad you're here. I know God had to send you because He knew we needed each other. What I feel for you can't be expressed in words; if it could, it would be words no one has ever heard. You were my friend, now God has made you my world. You're the best thing that has happened to my life. You've given my heart the fulfillment to feel joy inside; you have taken my heart on a journey it has never been on. I didn't know something like this we have could exist; only God could create this. Sometimes I wonder what to call you, Audrey, but I'll call you what you are . . . My Angel.

I Am Potential

When the rest have failed I will succeed. When the rest have come and gone, I'm still standing. You don't know me, yet you judge me.

What you see is what you get. Nothing more... nothing less. I'm above and beyond all the rest! With the odds against me, I still rise. When they all said I couldn't, I showed them I could.

Everything I do, I do my best effort, and that is all I can do. No man or woman alive has witnessed the struggles I survived. Regardless of the hardship, regardless of the pain, I have to subdue... I believe in *me*!

Where do you stand in life? Do you know you have the *potential* to become any you you want, and overcome anything that stands in your way to success? I stand out in the crowd. You can see it in me... I *walk* it, I *talk* it, I *show* it. I am what you are not...

I AM POTENTIAL

Things Change

I never thought I would fall helpessly in love. I never knew what real love felt like, but I do now.
Things Change

I never thought about getting married and settling down and having one woman to spend the rest of my life with, but now I have…
Things Change

I never thought I could feel so strongly about anyone in particular, but since she has been in my life, she has changed the whole picture… The way I think and my image…
Things Change

I never knew love could be this strong and be so deep but it is…
Things Change

I never gave my heart to anyone because I thought love was just another one of life's games, but it's not…
Things Change

I never knew my heart could crave someone as much as it craves you, but now it does…
Things Change

I never thought anyone could ever love me, make me happy and make me feel so complete the way you do, but you do…
Things Change

I never knew anyone in this world could soothe the pain my heart possesses and make me smile again, but you have…
Things Change

I never knew GOD would bless me with such a special person in my life to where I would want to change my life and be a better person, but He did…
Things Change

Don't ever underestimate the power of love and the ability to love because…
Things Change

I'm Human, Too

I'm not perfect. I'll be the first to admit it. Nobody in this world is sinless, not even YOU! There is no justice in murdering another human. I don't care how the states try and disguise it…Two wrongs don't make it right…

I'm Human, Too

You see my faults, but you don't give a damn about my pain, or maybe if I have changed. There is no way you can camouflage this DEATH PENALTY as justice. When you sentence a person to die, how do you sleep at night, or sit at the table in front of your family and say grace, day after day? Regardless whether you want to admit it…

I'm Human, Too

I can't change the past, but with the help of GOD will it make a better future for all the victim's families by killing me? It cannot bring your loved one back. This is a fact! By killing me, do you think that is going to soothe your heart's pain? What kind of lies are you feeding your brain? Love is the only remedy to pain! How can you sit in church and call yourself a Christian knowing Jesus was executed, too? You don't have to acknowledge it, but…

I'm Human, Too

You can change the protocol and use just one drug. You can even change the reason for the Death Penalty. You can change time, but it will never, ever be justified. When it is all said and done, you can't change the fact…

I'm Human, Too

Now that You're Gone

Heaven is your home
Thank you for the time we shared
Just know that we cared
May your beautiful soul rest in peace.

The body can die, but the soul lives on
And our memories of you
Will live in our hearts forever.

People need to learn to enjoy life
Every precious second counts
You never know when it's your last.

What you leave behind is
Not what is engraved in stone monuments
But what is woven into the lives of others.

I miss you Kaelynn,
I know life must be carried on
…Now that you're gone.

My Sister's Faith

The Way it Began

This is so deep; it's going to take a minute to explain.

They sentenced me to death: My sister's faith is all I have left.
I let her down again; she refuses to accept defeat, she's putting
the game in my hands again.

God, where does my road end? Do you ever get those prayers
that I send?

I never really believed in Angels, but when I see my sister
"Debra Neil,"
I have to look at things from a different angle, because she's in
the dictionary, under the definition of an "Angel".
The world can be against me, I don't care. As long as she's
standing there with me, because, with her faith, I know we can
come out with a victory.

The Way It Was

When I tried to take my life my sister's faith didn't let me die.
Just writing this poem brings tears to my eyes. I wonder does
she know she's always been my hero, she's everything to me?

Even when I did her wrong, she treated me with kindness; this
is a type of love you just don't find. If I had to trade my life,
just to see her live another day, I would.
You're the best sister a brother could have. She won't bite her
tongue, she stands firm. I often wonder where does all the
love she gives comes from?

God knew what He was doing when He made you. He took
His time. When He designed you, He destroyed the mold; you
got a heart of gold. You're the Queen of my soul.

I just thought I'd let you know, you mean so much to me that words could never express what I'm feeling in my chest.

The Way It Is Now

I wish they had some type of award because as a Sister, you're outstanding. If I had a million dollars I'd give it to you just to try and repay you for some of the heartaches I sent you through. But through it all you stayed true.
And I just want to say, "I love you." You are my champion because you are a true fighter. We have come a long way by God's grace and my Sister's Faith.

Not A Chance

Twenty-nine days is all I had
God has taken me home
I never was able to talk
or walk or experience
the many things life has to offer
A lot of people all they do is complain.

My Mom and Dad name me "Shane".

People don't realize
the gift of life is so precious
People need to learn to enjoy it
cause it is a precious treasure.

My cries can no longer be heard
I'll never go to school
or learn to tie my own shoes
One minute I was here and the next
I was gone... Not a chance.

Ker'Sean Ramey
#999519

Stand Up to Injustice

Stand up to injustice,
and let it be known.
You will not tolerate it,
even from the king on his throne.
Stand up to injustice,
cause it could happen to you.
And then what would you want
the rest of the world to do?
Stand up to injustice,
in every shape, size, and color.
Then come together to stop this
from going any futher.
Stand up to injustice,
for Black, Brown, and White.
Because you must realize
this is an all around fight.
Stand up to injustice,
for you and for me,
'cause one finger can be broken,
but a fist can not be too easily.
Fight this injustice,
whether a woman or a man,
'cause seperated we fall,
but United, We Stand.

Focused

In this life I live, if you can call this livin',
I'm like a hungry tiger, focused and driven.
I have no time to deviate from the path,
'cuz with each breath I take, it could be my last.
I'm serious about my current situation,
knowing they will kill me, without any hesitation.
I've prepared my mind, so I'm ready for whatever,
walk to my death, and let 'em murder me, never.
Staying focused on the prize,
I got a goal in my head, and a gleam in my eyes.
Keeping my head above water, not drowning in misery,
I've got my mind right, so I won't let it get to me.
I know my adversaries are praying I lose,
but you can give that up, 'cuz I done paid my dues.

The Storm

I sit back and watch the rain fall slowly as I write these words.
I hear the undeniable destruction as the thunder hits its
victim.
I've decided against being a victim, so I look for a place to
hide
only to find there's nowhere to hide.
I must now use my mind to circumvent the destruction.

While I think of a plan, the lightning attempts to distract me.
But it instead helps me to see through the debris.
I notice an underground basement door,
so I decide to go there to get my thoughts together.
Thinking I've beaten the rain, I can't help but
notice the wet spots that splatter the page.
I look up but see no holes in the ceiling,
giving me the impression that I'm hallucinating.

While searching for an external answer
I've found the answer is within.
The dark clouds above are not dark clouds at all;
they are the painful yet true memories that stain my brain.

And the destruction I attempt to circumvent is
the destruction of the Texas death penalty.
The lightning that lit up the sky allowing me to see wasn't
lightening,
it was the small but very helpful knowledge that I acquired.

And the rain that slowly fell down and splattered the page,
this was the pain and frustration being released after being
repressed for so long.
These tears that run down my cheek are alive;
they scream . . . loneliness, betrayal, distress.
But the words that were smeared on the page by the endless tears
weren't words at all.

They are reflections of myself in times of need, discomfort
and anguish.
They are my painful reminders of reality;
they are windows enabling you to look deep into my mind
and heart to see me for what I am: a human.

I Believe

I ain't M.L.K., but I believe a man who won't die for something
is not fit to live.
I don't look like Malcom X, but I believe in accomplishing my
goal
and defending myself by 'any means necessary.'
I'm not Obama, but I believe it's time for a change.
I'm not famous like Jesse Jackson,
But I believe the only justification for looking down on
someone
is to pick them back up.
I have not seen Maya Angelou, but still I rise.
I don't write like Langston Huges, but I'm still here.
I'm not Ray Charles, but I have to believe in what I'm doing.
I'm not the perfect dad like Bill Cosby, but
I believe the key to failure is trying to please everybody.
I'm not Charles Darwin, but I'm struggling for existence.
I wasn't a slave like Fredrick Douglass, but I believe
if there is no struggle, there is no progress.
I don't fight like Muhammad Ali, but
I believe anyone who isn't courageous enough
to take risks will accomplish nothing in life.
I won't compare myself to George Jackson, but
I got blood in my eye.
I ain't Henry Garnet, but I believe no oppressed people
have ever secured their liberty without resistance.
I don't have a reputation like Marcus Garvey, but I believe
men who are earnest aren't afraid of consequences.
I'm not Mary Bethune, but I believe next to God
we're in debt to women
First for life itself and then or making it worth living.
I'm not a Panther like Fred Hampton, but
I believe that politics is nothing but
war without bloodshed and war is nothing
but politics with bloodshed.
I might not be Nelson Mandela, but the struggle is my life.

I ain't Huey P. Newton, but
I believe in Revolutionary suicide.
No matter how hard the journey
I can't quit, 'cuz I believe.

Dear Mama

Mama let no tears fall from your beautiful eyes,
'Cuz I know these cowards would love to see you cry.
Give 'em no satisfaction as you smile and keep moving,
Letting them know it's all good, and we ain't losing.
Never will you see her head looking down,
'Cuz she's a Queen, and on her head in a crown.
All the things she's been through in life,
She's a mother, a sister, and a wife.
They see her confident walk as she stands strong and tall,
She's a beautiful illustration, of Love conquers all.
She is not only my mother, and only true friend,
She's down no matter what, and with me till the end.
I'm with her in her mind, spirit and heart,
Forever and always, till death do us part.

Dedicated to my mom: Terral Ramey

My Thoughts on Self-Determination

Self-determination is vital not only in business but in life. A lot of time people without self-determination are preyed upon by the stronger individuals who see their weakness. I've seen this my whole life but failed to "recognize" it until I got locked up and started reading. Now I see that this is prevalent in life. I can now say I honestly possess this trait, in my earlier years (I am only 23), I didn't have strength to do it. My situation has forced me to become mentally and emotionally stronger. If a person does not possess self-determination, they are open to the persuasion and manipulation tactics more so than if they possess it. This hurts a lot of people 'cuz they don't want to seem soft, friendly, weak, or they don't want to be ridiculed by their peers. I've learned that if I allow someone else to determine my life, then I'm not living my life. I'm living their life. I'm only a "puppet" on a string and if your parents can't determine your life, then no one else should be able to either. I used to be scared of what people would say but now I see it like this: If a person can't respect me making my own decisions, then they can't respect me. I'm not saying I don't accept advice 'cuz I do; I don't know everything, so I need advice, but give me advice and allow me to make the decision on my own. This is only my perspective of self-determination.

Lettin' Loose

With this pen and this paper, I've captured my emotions,
sometimes I'm full of rage, sometimes love and devotion

No matter my feelings, if they good or if they bad,
I refuse to conceal 'em, so I write 'em down on this pad.

Some can understand me, due to their experiences in life,
others just overlook me, like the moon and the starz at night.

Though they may try hard, they still cannot see,
'cuz they look with their two eyes,
instead of with their third eye, like me.

You are watching my reflection as it slowly fades away
but this is a piece of me, so
I'll live forever and a day.

John H. Ramirez Jr
999544

In the 8 months that I've been on Death Row I've learned a lot about myself, and how much looks can be deceiving when it comes to others. The things that were not so important on the outside are now constantly on my mind. They say you don't know what you have 'til you don't have it. I know it's a cliché and all, but it's so crazy how true that's become for me. Now family and communication are #1 in my day-to-day life. Don't get me wrong now, family has always been important to me, but now I see my people in a whole other light. Education wise I always did just what was neccesary to get by, never aiming to over achieve! Now-a-days it seems I have an unquenchable thirst for knowledge. Reading has become a great hobby of mine, I've read more books in my 20 months of incarceration (12 months in county jail and 8 on the Row), than I have in my entire life. They can take away my liberty but my mind is forever free! I escape these walls every time I travel to the fictional worlds of the books I read. Daydreaming has become another of my hobbies! I picture myself still living in the free world and experiencing things I never got a chance to. I see now all too clearly the mistakes I made in the past. But I don't regret or feel sorry for myself, I just count it all as a lesson learned. Some things will never change though. For instance I still love to eat sweets and joke around. As long as I can wake up and still find humor in this life then I'll be alright. You gotta be able to laugh in a place like this, not that this is a tough place to be, it's just extremely boring. Don't believe the image that Hollywood puts forth because it's nothing like that. Instead of a place where respect is a way of life and disrespect is a way to feel the sharp end of someone's shank, it's almost the complete opposite! On a daily basis you'll see 20, 30, 40 yr. old little boys. Childish and immature in the way they present themselves and behave. Some believe throwing shit and piss on someone is getting down and being a badass. Others get upset for a number of

reasons and start little fires in front of their cells. Everyone's different so I can't criticize no one, I'm just giving you my opinion. Oh and then there's the cell warriors or spit boxers or sidewalk sissies, whatever you call them they're one and the same. Those are the people that spend a lot of their time yelling threats and all other kinds of things that they can never actually do because they're locked in their cell . . . Hence the words "Cell Warrior." On a more positive note though, there's things that are available to us to help us do our time and not let the time do us. For example, pen-pals are very popular and we are able to reach out and find us some pen-pals here in the states and even overseas. They are a great source of help emotionally, mentally and sometimes even financially if you're lucky. I have two overseas pen-pals as of now that are completely different from me, which makes them such interesting people! It's cool to connect with people like that so far away. Writing to people in Germany and England is something I would've never done in the free world. I also got a pen-pal from my home town named Nana. That girl gots a lot of love for me, sometimes I feel like me and her go way back like Pampers and Similac. They say blood's thicker than water, and my parents and grandmas have brought true meaning to that saying for me. My mom constantly writes me and keeps me up to date on all family matters while also keeping my spirits up and offering encouragement. One grandma keeps me in touch with my little sister and is also my financial rock. While my other grandma keeps me in touch with my little cousins and uncles and also helps me finacially. Since being incarcerated I've started to do drawings to send to my people so they have something from me to cherish once I'm gone. I can't draw freehand, so I use patterns and copies to get the outlines, then I'll do the details, coloring, and shading. I recently recieved my first visit and it was my son and his mother. He's 3 years old, potty trained, and talks a mile a minute. Concerning my son, the thing I'm most grateful for is that his mom isn't a low-life unfit mother. She always works and continues to better her life, which lets me know that my son will have a good life and always have what he needs. I feel blessed to even have a son

because my son was born while I was a fugitive of the law. I caught my charges in 2004 and the very next day I was crossing the border into Mexico! I stayed in the border cities for the first 2 years, so I met a lot of Americans who would cross into Mexico to party, go to the clubs, and go shopping. I met my baby's mother in '04 and traveled Mexico with her. When she got pregnant I moved back to one of the border cities so she could regularly go to the doctor here in Texas. She crossed when it was time to have the baby, so my son is an American citizen. I loved everything about Mexico, the culture, food, women, and last but not least, the corruption. Because everything's so corrupt I was able to last as long as I did. I knew once I was caught I would more than likely never walk the earth a free man again. So I enjoyed my freedom while I could. My trial was a joke, but that was expected since the media and my co-defendants found me guilty before I even went to trial. I'm a person of faith and also believe everything happens for a reason. I love music, especially if it has a good beat and lyrics that speak to me. I used to like nothing but gangsta rap, but I spent a lot of time on the internet downloading music and watching music videos. So I came to find out that I enjoy all kinds of music. Alternative rock is probably my favorite though because I feel most lyrics speak truth. To show I like all kinds of music, here's a few examples . . . Linkin Park—*Hybrid Theory* & *Reanimation* albums, *Hotel California*—Eagles, Metallica—Black Album, old school Bushwich Bill, most Swisha House Artist, Intocable, Fama, Los Campiones, Red Hot Chili Peppers, Hinder, Pappa Roach, Willie Nelson—*Gravedigger*, All-American Rejects, Jay-Z, Twista, Kanye West, Maroon 5, One Republic, Hoobastank, and many many more! The places I've been to are California, Colorado, Nevada, Hawaii, and of course Texas and Mexico. My city is by far the best place of all . . . Corpus Christi, Texas, home of Selena and Eva Longoria, Texas A&M C.C., The Harbor Bridge, Texas State Aquarium, U.S.S. Lexington and a whole bunch of other things that will take forever to mention. Plus C.C. is surrounded by beaches, which makes it a hot spot for Spring Break and summer vacation. It's crazy how life passes by so fast, and once your life is

being taken away, you realize there's so much more you want to do. Self pity is not my thing, so I'll do like I did during my time in Mexico, and just make the best of it and try to enjoy myself. During my trial while I was in the county jail I wrote a song just to put into words the feelings and emotions I was having. I guess it can be labeled a poem or even just a statement, but I call it a song because I sing it and it sounds badass to me! Well here it goes:

"Where did I go wrong?"

Where did I go wrong—I said where did I go wrong—
Go wrong—Go wrong—Where did I go wrong in this
life I lived —where'd I take that wrong turn to end up like
this—now I remember way back as a little kid—my life was
just so much fun—it was nothing but bliss—now I used to
get in trouble every now and again—but not to the extent
that my life would end—and look at me now facing life in
the pen—Damn I just can't believe this is happening—I said
where did I go wrong—Go wrong—Go wrong—Where did
I go wrong—Now this is all life's plan, that's what I have to
believe—because if I don't then this all brings me so much
grief—They say I robbed two people and I killed a man—how
I could do such things—I'll never understand—And the girls
I was with put it all on me—they say I planned the whole
night like a crime spree—then the media's straight discrediting me—putting me out there like some crazed personality—I
said where did I go wrong—Go wrong—Go wrong—Where
did I go wrong—Now these sinful ways I'm trying to leave in
the past—even though I feel the present hitting me too fast—
And the people all around me are so quick to judge—but they
don't really know me or who I really was—So I live and learn
and grow a little more wise—As I start to feel the effects of
this life—But I can't hate or shall I say despise—'Cuz baby
reality has rudely opened my eyes—So now I realize that you
reap what you sow—So at the end of my days as the chemicals flow—as my life slips away and my body turns cold—

There's only one thing that I want you to know—that I made the best of what was left—And let my love show—But no matter what there's still something that I'll never know—And that's where did I go wrong—Go wrong—Go wrong—Where did I go
wrong!

I wrote this song after court one day in one sit down. I also studied my Bible a lot too during all these months. I'm not a holy roller or anything like that I just really enjoy learning the history and stories of biblical times. I guess if I would've went to college instead of the military, then Theology would've been one of my classes. Now to talk about the ultimate finale to most of us on Death Row . . . DEATH! My veiw points on death are simple, we all live just to die and at the same time are just dying to live. Most people are afraid to die but not me, I actually look forward to it. Don't get me wrong, I don't mean that in a suicidal depressing way. More like accepting the inevitable and not breaking my head or giving myself false hope. I refuse to lie to myself and set myself up for disappointment. But maybe if things go well I'll get my sentence turned to a life sentence. It's crazy how the State of Texas condemns us for alleged murders, just to murder US right back by lethal injection. So they're killing us after they say it's wrong to kill. Hypocrites! Prosecutors claim during *voir dire* that the main purpose of the Death Penalty is to deter others from committing the same crime. I guess society hasn't noticed that people don't think of the consequences when they're breaking the law, because if they did they wouldn't be committing the crime, to begin with. That kinda blows that claim out of the water. People are given titles and sent overseas for the sole purpose of killing. Then are brought back and are given awards and medals. We are a nation of murderers and killings . . . drunk drivers, drug dealers result in overdoses, abortion clinics, the FDA approves miracle drugs that later prove to cause cancer or tumors, tobacco and alcohol companies cause millions to die of lung cancer and liver disease, military personnel are killing people left and right.

Especially if it's to punish someone for that very same thing ... murder! And the way we are locked in our cell 22 hours a day is just insane. There was a Death Row Plan where we were able to have jobs and move around more. It is currently "suspended" and has been since 99! I think it's very important for us to be able to work and have more movement. Basically to be able to exercise our bodies and stimulate our minds. It is said that capital punishment is cruel and unusual, and I agree. Not only is the 3 cocktail injection considered cruel and unusual for dogs but is still being used on humans. . . . We have to live day in and day out knowing when we are going to die! Society in general is able to go about living a normal regular life because they don't know when it's going to end. If people knew when and how they were going to die, it would be mass panic, complete hysteria. We have to live with that fact everyday, and that in itself is cruel and unusual. Under these circumstances you will still find a humane side to the Death Row world. Being all condemned creates a sort of brotherhood or camaraderie. Of course, not with everyone because there're still enemies and people that no one gets along with for various reason. For example, snitches and child molesters are the main ones. Now back to what I was saying about the humanity within these walls. Most people who do not regularly have money on their books, are helped out by others. On commissary day if you don't get anything, there's usually a couple of guys that will send you a few soups and chips or what not. You ain't got no stamps and need to send a letter off to your attorney or family, usually someone will lend you one or just give you one. You ain't got no reading materials, a lot of guys will share their books with you. Little things like that puts us all on some kind of common ground. I saw that the 2009 book is titled "Upon this chessboard of night and days. . . ." Chess is a big part of life back here. It's a thinking man's game, and it helps keep the mind sharp. I just learned how to play in '08 while I was in the county jail, and it's a good way to pass time. I'm getting better with time, but still there are guys here who are straight cold on that chessboard. There are still many aspects to life back here on the Row, but some

things are better left unsaid. Well I hope all who read this have enjoyed hearing my opinions, veiw points and the little bit of background history of my life! I want to send my love and thanks to all my family and friends out in the free world. Especially my mom for bringing me into this world and putting up with me all these years. And also to my father and both grandmas for being my foundation and support team! MUCH LOVE!

John H. Ramirez Jr.

"¡Eno Tsol!"

"The world is filled with childless Fathers, and Fatherless sons. . . ." Love you and miss you my baby boy "Izzy"!

"It never rains, but it pours!"

"Believe nothing of what you hear, and only half of what you see."

"What I believe I should believe, is better than what I believe!"

"A rose is a rose by many names, but it is still a rose."

"You don't know what you have 'til you don't have it."

Mark Robertson
#000992

When It's at Your Door

You sit, lay the tax, and wait for nothing—
another damp night in the yellow light of cheap bulbs
within the gray walls amongst men,
killers, who struggle for their lives.
"You will be laid into the earth" they say,
"Laid by men in linen clothes and white linen hats,
For the state doesn't buy wool."
Hmpf.
You sleep at dusk, dawn, night or day.
It doesn't really matter.
It doesn't matter at all.
You have the responsibilities of a rock:
just sit and wait till some force comes
and holds you sway and makes you cry,
like the cold, hard men whom I've seen
with tears in their eyes.
I shouldn't be surprised.
It drives you mad. It drives you crazy,
but you cannot go insane;
the sanity is all that keeps you going,
when darkness surrounds your day.
And when the sleep does not come
you just lie there, wearily,
wondering when you'll fly out of your body
and into the bliss of night, still wondering
if there really is a hell; a place where you'll burn
for the pleasures procured.
So you count the tickets of sin,
the receipts of your deeds, but
you're always in the red.
And you hear the voices prattling all the time,

some of god, some of money, some of love gone by,
and you think how stupid their conversation is.
They argue and scream, making a constant fuss,
yet if they are silent, mute and still,
then perhaps, just perhaps,
they will become just like you.
But do you really fear?
Yes, perhaps a little, as the child,
who once feared the dark room
with the open, closet door, yet as with all trips,
as with all fears in time, you learn to learn
what's feared and what's trite,
and you care for neither, for neither care for you,
so over you roll, slapping your pillow,
looking at the time, hoping your neighbor
does not hear, cannot hear,
the thoughts within your mind.

Martin Robles
#999457

I Am Joaquín: An Epic Poem, Part Two

My Lord.

My Lord. . . 41 years have passed us by. . .
41 years have passed us by. . .
And thanks to the Holy Spirit I'm back alive. . .
Yea, I'm back alive. . .
Can you see? Can you see?
I am Joaquin.
Have you heard of Me? Have you heard of Me?
I am the Mexika King and the Christian Christ
The Christian Christ!
Resurrected and brought to life
brought to life
I am the young and the bold
The young and the bold
Except this time
Except this time
I'm writing from a place called death row
A place called death row
How did I get on death row?
death row?
Rudolfo. . . is that you? Is that you?
where are you?
who is it? who is it?
carnal.
you've left me at the mercy of the seasons. . .
Mercy of the seasons. . .
where everyday I fight demons. . .
I fight demons. . .
Roaming the winds I've waited 41 years
41 years!

To a new master to unleash his sword and conquer my words
I said conquer my words
I am Joaquin
Bonafide like the Aguila that dominates My sky
dominated My sky
New to the rules yet born to rule
New to the rules yet born to rule
Created from incest out of force not love
out of force not love
Confused but never abused
Confused but never abused
Yes
I Am Joaquin
New and improved
New and improved
God I Love this
God I Love this
I can feel His strength
I can feel His strength
His blood is pure
His blood is pure
Just as I predicted 41 years. . . 41
What year are We?
What year are We?
2008
2008
My Lord times have changed
times change changed
We can now regulate
We can now regulate
El Mestizo is a force
El Mestizo is a force
La Raza Unida is a reality
A reality and the finality
My Sangre is stronger on Cortez's side of the family
side of the family
where are we?
where are we?

In Texas!
I'm in Texas!
The generations have been good to me.
good to Me!
I Am Joaquin
The creator of Aztlan
And father of My Raza
I said Father of My Raza. . .
Mi Raza fino y poderoso
fino y poderoso
Yo Soy El Verdadero
El Verdadero
Manifested through the ages
through the ages
From poor boy with a few toys
with a few toys
To saint who goes hard in the paint
who goes hard in the paint
I Am Joaquin
Fatherless, sisterless and brotherless
I said brotherless
I Am Joaquin
The Rock who can't be stoped
I Am Joaquin
Gladiator and warrior in times of battle
In times of battles
I Am Joaquin
Shot up and still alive
Shot up and still alive
I Am Joaquin
Tortured and laughed at
Tortured and Laughed at
I Am Joaquin
The true story and glory
I said Glory
I am Joaquin
Guardian and defender
of My constitution

I said My constitution
Written while in desolation
I am the Prince in Meditation
And conquerer of My nation
I Am Joaquin

The Love For Christ

It all started long ago, the faith, the love
And yellow brick road.
Now that I'm here, I want the people to hear
That my love for Christ can never be smeared.
On November 14th, I made the decision
To clean my soul, my mind
And let go of the times.
Family and friends, hear my cry!
The only true man is Jesus Christ.
Everybody doesn't feel Him
And misinterprets His rules.
But on Judgment Day, He'll be rude.
So people, listen to my words
Of a gangster gone nerd.
Accept Christ and the Lord will hear our prayer.
Christianity is humanity
And nothing can stop me
From growing and learning
In the Lord's understanding.
I know a lot of guys who don't want to let go of the life.
So think about the Lord's sacrifice
He died for you and me
So that we could live in peace.
All I ask is that you believe.
Drop the gangs and pick up the cross
So that our generation and nation don't become lost.
The whites, the blacks, Asians and Vatos
What more do you want?
You banged, you slanged and represented a gang
And now our heads are sadly hanged..Let's all be strong and
show real leadership
By building our communities
In the Lord's humility.
God bless us all in mind, spirit and soul.

Vaughn Ross
#999429

Happily Ever After?

Happily ever after is the customary ending to the fairytales that so many people love and cherish. Some love these tales so much that they begin to believe in them and live their lives accordingly to achieve the happiness they portray.

In my short life I have come to find out that life is not a fairytale. It is nothing like the stories you read or had read to you many times as a child. And it does not always end happily ever after as those stories go.

In fairytales life goes on forever and never ends. Rarely does anyone ever die. Usually in these tales life is always happy. Until some tragic event happens that sends the lives of the fictitious characters in a spin. Then before the imaginary tale ends some heroic character comes in and commits a courageous act of legendary proportion that saves the day.

That does not happen in life, at least not the life that I have lived and know. How about you?

Fairytales are not real, but life is. It ends just as it begins. In between that time there you live to experience highs and lows, sunshine and rain, happiness and sorrow, joy and pains.

Life is not a fairytale. In most instances you can say that life is a journey. One that we all must travel. Through our lives as with any journey we pass from one stage to another. Learning and growing from each experience if we are lucky enough to acknowledge the lessons that life presents to us. Some stages are harder then others, if we don't learn to progress and overcome them.

Life here on death row is no fairytale. I must say that it is more like a nighmare I'm forced to live. Day after day we here are subjected to the inhumane treatment by others who we must trust to do right by us. That is a contradiction in itself. How can anyone trust those who are authorized to not only hold them against their own free will, but also kill them?

For many of us there will be no happy ending. Our lives will end through the intentional act of others. A violation of the law against murdering another human being.

The tales of our lives are missing the magical creatures and heroes to rescue us. In the end we will all die. For the less fortunate of us we will die in the death chamber strapped to the gurney as a lethal dose of drugs is pumped through our veins. A method of death unfitting for an animal. There may or may not be any witnesses to this event. I can understand why. Who would want to see such a thing? And why? I would not want to put my family, friends and loved ones through the torture of watching me die. Nor would I want to watch someone glorify in the observation of my demise.

Life on death row is very rarely happy or ends happily ever after. Yet it is the only life we have. All life is worthy to live even if it is not lived happily ever after.

Inhuman?

As I sit in this cell
Caged away from society
Confined for and from the majority
Of my days over these indefinite years
My mind ponders a heavy weight
A question prevalent in human fate
I often wonder and debate.
When did I become Inhuman?

Did it begin when I was accused
of committing a capital offense
Murder in the highest degree
Such a heinous crime
That has been repeated by mankind
Throughout all ages and time
Believed in some cases
For the betterment of the human race.
And I am Inhuman?

Or did I become Inhuman?
When I was convicted
By a simple decision
Of inconsequence
The verdict by the court
Was to hold me guilty of an offense
One finds wrong and sinful
Even though it was never proven
That I carried out such a grave act
The same act will be carried out on me.
Does that make me Inhuman?

Is it Inhuman?
How I was treated
During this ordeal
Chained like an animal

Shamed and defamed
Stripped naked of my rights and dignity
No longer guaranteed Life, Liberty or property.
Is that Inhuman?

Am I Inhuman?
No, I am not!
Because I did not become of it
As the others who treated me so.
Through this madness I still maintained
All my human qualities
I still care and love others
Cry tears for my slain brothers
And share their pain
Just the same.
Now who's Inhuman?
Humans or Humanity!

A Diamond Is a Diamond

A diamond is a diamond,
but not all are the same.
It's better to have one
in the rough,
then to take a flawed one
and try to make it perfect.
Because no matter how hard you try
the flaw cannot be removed
without most of the diamond being consumed.
But a rough one can be polished smooth.
Both are formed through
heat and pressure
yet one withstood its adversities intact.
So give me the rough one
cause in the right hands
it can be tooled.
All in all,
A Diamond is a Diamond
but its value may differ from one to the other
Not until you truly examine them
do you see that one is more a tinket.
Yet in the end,
They both are still jewels
In the eyes of the one who treasures it.

Time

With time,
Our past is a burden
That we carry along with us, as we harbor both good and
 bad experiences.
The present is a gift
That's meant to be enjoyed, Now!
And the future is a dream
only seen in the mind
in small glimpses of scenes
never fully realized.

Max A. Soffar
#000685

My name is Max A. Soffar. My execution number is 00685. After throwing away several requests that I submit some contribution to this project, I have decided to show you what is being done to me. I want you to see, to judge, and to free or kill me yourselves.

Let us do this with the understanding that I am a broken man, who hurts so badly after 30 years in a cage for a crime I had nothing to do with at all. I do not offer just talk, rather I offer law professors and judges from the most lethal United States Federal Circuit Court in the United States. Now, after legal opinions were written and one judge said he could not be a part of executing me because I am innocent, I was granted a new trial.

I went to Houston in 2005 for that trial. I had hired attorneys who knew who the real killer was, and where he was. I had witnesses, and I had proof I am innocent. Then when it was time for the trial, the witness who would testify to the jury that "The person that is the killer admitted to him he in fact did this crime" was threatened by the district attorney that he could be charged for not telling this in 1980. So he did not tell what he knew, that I am innocent. Then as my jury was seated, and I started to show them this injustice I have lived for 30 years, this judge refused to let us present to my jury the facts that show anyone who investigates this or sees them that Max A. Soffar is innocent.

The Houston District Attorney now has this proof, and she allows me to rot in this cage like I am deserving of it. Though what she knows is this: I am not in any way involved in this madness that occurred in Houston on July 13, 1980, that cost the lives of three young people and the unimaginable suffering of a fourth victim.

The Innocence Network with the University of Houston has fought for me for over a decade with Professors David Dow and Jared Tyler. The ACLU is fighting for my freedom along with Kirkland & Ellis in New York. They know that I am innocent is why they fight. Even knowing I am innocent, the DA Pat Lykos pushes for my LETHAL INNOCENCE INJECTION to be carried out. Do people care? Why is this allowed to continue? WHY?

Any advice or suggestions to bring this case before the district attorney that "claims" to have formed a "special panel" to look into matters involving the innocent would be appreciated very much. Pat Lykos in Houston promised to help people like me (the innocent). She has NOT done a thing, even knowing I have proof and witnesses. I am, in FACT, innocent!

Richard Lee Tabler
#999523

Christ on the Cross

Before I'm executed and no longer have a chance, allow me to take one final, longing look back at Calvary's bloody banks. As the eclipsed sun tucked itself behind the trembling ground, a ground still wet with the cascading blood of a loving savior, Jesus's love was so awesome that it could only be depicted by the morbidity of His dying. Allow this condemned man, this Turlock California city boy, a final glimpse at the only hope his soul has of Heaven. Brush a tear from a face full of thanksgiving and look at His bruised, mutilated, and lacerated body. Look at the 33-year old body that could have been the object of some loving lady's desire. The body that was filled with such youth and potential now hangs from the cross like a slab of unused meat. From His beaten back to His ripped torso, we see a wounded knight without armor. His garments lay crumbled on the ground, the object of the desires of His villainous guards who now gamble up their leisure moments, waiting on the death angel to flap his wings in the face of the Savior. Ignore the ice-cream social pictures of modern artists who portray a sunning Savior, basking in divine light before an alabaster sky as He gazes listlessly and lovingly out at a dying world. Ignore their imagery of a prince clad in some magical loincloth that seems, even in the pictures, to be somehow superimposed on the body of this spiritual celebrity. When you look at this icon of grace, remove your religious glasses and you will see a sweat-drenched, trembling, bleeding offering. That crucifixion was a debauchery and degradation so horrible that it embarrassed the sun into hiding its face and made the ground tremble at the nervous sight of the King of glory. He hung dying as if He were the bastard son of Mary, not the King that He was—dying like a thief in the night! His body, twisted and mangled, was held to a tree and

suspended by nails as if some Marquis de Sade-type sadist had relished in torturing the innocent. To me, Jesus Christ is the Prince of Peace. But to them He was the entertainment for the evening. They stripped Him completely and totally. They humiliated Him by placing a robe upon His nude body and a crown upon His weary head, and then they amused themselves with Him. When they could do no more, they stripped Him of the robe and put His own clothes upon Him and led Him away to the cross. At the cross, Jesus again was stripped of His own clothes like the innocent animal in the book of Genesis was stripped of its coat of skin. Likewise, Jesus was made bare that I might be covered. Climbing naked upon the cross, He lay nailed to a tree! They then parted His garments among themselves and watched Him, naked and not ashamed! They watched until grace grew weary and mercifully draped a curtain over the sun, allowing darkness to veil Him from the watchful eyes of the unconcerned hearts. These are the eyes of cold-hearted men, men whose eyes are still darkened today lest they behold the wonder of His glory. That is why they can't see what we see when we look at Calvary! The Savior's head is pricked with the thorns of every issue that would ever rest on my mind. His hands are nailed through for every vile thing I have ever used mine to do. His feet are nailed to the tree for every illicit, immoral place you and I have ever walked in! Sweat and blood run down His tortured frame. His oozing, gaping wounds are tormented by the abrasive bark of that old rugged cross, and are assaulted by the salty sweat of a dying man. In spite of His pain and abuse, in spite of His torment and His nudity, He was still preaching as they watched Him dying—naked and not ashamed!

Charles V. Thompson
#999306

Fargo the Dog

Once, not too many years ago, there lived a dog named Fargo. He was an average dog, medium sized, your every day run of the mill dog. The young Fargo grew up on a farm way out in the country, well until he reached a young adult age in doggy years that is. The family that was Fargo's was a modest family, not too poor, but just barely getting by and making the late payments on their farm.

As Fargo matured into a dog from a young carefree puppy, he noticed things changing around the farm. First to go was the car. Fargo never liked cars—it always meant a trip to a vet. Nope, he was terrified of cars! The second thing to disappear was the farm's tractor—that was last year also. Then right after harvest the strangest thing happened. One day a huge long truck came. Fargo went to investigate, after a rush of all kinds of wonderful smells, things and places he had never known. It all hit him; he sniffed the truck and knew something was wrong. Way too many humans used this truck.

Fargo went to his favorite shade tree—laid in the grass in the shade with his bone from yesterday's supper. As he lay there watching, his family started moving all the stuff out of the farm house into the large truck.

Well, thought Fargo, there is something wrong here. So Fargo went to investigate. When he got near the house he got shooed away, practically swept away by the lady of the house. Fargo knew all too well what that broom felt like. More than once he had been chased away from the animals with that broom. Especially the hen house, those noises and squawking birds always gave him up with all that clucking and racket.

It was impossible for a dog to play with these fellow farm animals without the lady chaining him with that darn broom! He still planned to chew that broom up like he did her new smelling shoes and that hat. Ha, he would show her!

By that evening Fargo was hot and thirsty, so, as he did every day, he went down to the creek to get a drink and swim around, and with any luck he could find some more of those funny four legged things that lived in those shells, turtles he had heard them called. Sure couldn't eat them, but BOY what fun it was when Fargo got to play with them.

As the sun started to set Fargo returned to the farm house, and much to his surprise, there were no smells of food as usual . . . the large truck was gone. In fact, as Fargo rounded the house everything and everyone was gone! OH NO! Fargo started running and barking all around the house. Nobody came out as usual.

Well, Fargo decided that for once he would sleep on the porch—that always got him plenty of attention—he wasn't allowed to be on the porch; there were always too many good pies and foods cooling for a dog to be hanging around. Often enough that broom came out and out the door Fargo went! Fargo slept, and dreamed about that truck. What could it mean?

In the morning, as the sun came up, Fargo then noticed that the rooster didn't crow, no pigs were grunting, no animal noises at all. Oh no, Fargo thought, this is really creepy. It was totally silent—everyone was gone!

Later that day his master returned in the family pickup truck, the old truck they kept. Old Fargo could hear it coming down the road, all the squeaks and sputters and weird noises it made. He knew it was them! Boy, Fargo got so happy he nearly wagged his tail right of his rear! He got fed, petted, and told they were going for a ride. Oh boy! Fargo barked. His master yelled, "Wanna go for a ride, boy?" "Woof, woof,"

barked Fargo! Fargo loved riding in the truck! All kinds of good smells and neat sights could be smelled and seen from the back of that old truck.

After what seemed like forever they arrived in a big city. Fargo was terrified! His family came out to greet him: "hey boy," everyone yelled. He was so happy to see them all; they all were glad to see him too. He barked and they played. It was good to be with his family again.

As everyone gathered around, Fargo just couldn't figure out what he did to get so much attention, but he sured loved it and was soaking it up. About that time the landlord of the apartments came out and greeted everyone. "Who's that young fella?" "Woof, woof," barked Fargo. He didn't like the landlord man; he was creep! Then he heard his name: "Oh no! Not Fargo too!" Fargo's ears shot up when he heard his name. He couldn't understand, but he heard his name several more times; then back in the truck he went. "Oh boy! Another ride!" thought Fargo.

A little while later they stopped and his master went in the store. Fargo watched as he came out with a leash and collar. He knew what for from the last time he wore one, his last experience tied up was nothing pleasant. Sorry bud, his master said. He was leashed and collared and they drove for a while longer . . . then they stopped and a man Fargo recognized as a friend of the family came out to greet them. "Hello, Fargo," he called out to Fargo. Fargo got out and greeted him. While smelling around the yard and house Fargo heard the truck start . . . wait! He ran. His master was leaving him. He jumped up in the cab of the truck. "Whoa boy!" his master petted him and told him he had to go. "Long goodbyes are not my specialty, boy. Gee, sorry I have to go on. You can't live in this apartment, boy. I am sorry." Fargo whined and he knew his master was leaving him with the friend. He started to close the door and for a minute Fargo went willingly—but he refused . . . so his master picked him up and handed him to the man. As

the truck drove off Fargo wiggled loose and took off after it—barking woof woof woof! Wait for me!

Fargo ran and ran for what seemed like forever! The faster he ran the longer he chased the truck—but it was no use—he couldn't catch it! Fargo watched as the truck rounded the field—he cut across the field and tried hard to catch his truck—but it was no use—he was gone.

It was then that Fargo stopped and looked around realizing he was lost, all alone and scared—in this big city. Fargo whined and he heard a car coming—he ran—Fargo was scared of cars, he had almost been hit—and run over . . . as he tried to back track—he wandered into a neighborhood.

Fargo wandered around for days—eating out of trash cans, chasing cats and running from cars. He got scared several times with all these new big city noises, and he just didn't know what to think of these big city smells! What a strange place Fargo was in.

The next thing Fargo knew, he was caught in some kind of rope net, he struggled and fought to get out of it—but it was all around him, as he looked up he saw a man in uniform—he yelled: "I got ya little fella—calm down boy.". He was then put in a truck with a bunch of cages full of dogs! This was very scary for Fargo; he didn't know what was going on—he was a country dog—this big city was indeed a foreign place.

Soon the truck arrived at a kennel boarding house— Fargo had been to a kennel once—and he quickly recognized the smells of fear and death inside. He was trembling with fear now. He hated visiting doctors or vets as humans called them.

To this very day Fargo is locked up in the dog pound— he can't sleep, it's too noisy, the food is gross, the cages are

small—and he is so lonely. Several times a lot of people will come in and pick a dog—sometimes the dogs go down the hall and never come back, all dogs know the exit is the other way—and death's smell lingers in the air. Fargo wakes every day sitting in his cage hoping, and waiting—that somebody will come get him. He patiently awaits his fate—whatever it may be—to be happy and free—with a new family—he dreams of his days on the farm, in the shade of that tree. Fargo has gone far—go far, Fargo hopes to go far, far away . . . some day.

Carlos Trevino
#999235

Heartbeat

One of the most frequent questions people ask is, "How do you handle or deal with being on death row?" For everyone on death row, there would be a different answer. Just as if you were to ask, "What is death row like on a daily basis?" You'd get a different answers. So how do I handle being on death row and in solitary confinement? (Which means being in a cell for 22 hours/5 days a week and 24 hours/2 days a week).

That question is easy to answer. I listen to my heart. I don't mean as to what it's telling me, I mean to actually listen to the beat of my heart. Of course there is a history to it. If you have read part of my life story, you'll know that my mother used me as a punching bag when I was a child. This is how it came about as to me listening to my heartbeat. It was also how I learned how to deal with physical and emotional pain. Not that it did away with emotional pain, but it helped me escape the world I lived in. Almost like a drug. Of course it wasn't addicting, but I needed it, for it was my safe place.

Now that I am 34 years old, I find it amazing how I can express secret places of my heart and mind. I am not scared to express what I actually carry in my heart.

When my mother would go on one of her rages and beat me senseless, it was then that I discovered my safe place. When she was done beating me, I would go to my room, or anywhere away from my mother, to finish crying. I would lay down and close my eyes to escape the world before me. As my whimpering and tears slowed down, I would cover my ears and my heartbeat would come alive. I am not sure

when exactly this came about, but most of my memories go back to when I was eight years old. As I listened to the beat of my heart, my tears would stop falling and my breathing would become normal. The only thing I could hear was my heartbeat with the slow breathing in the background. Within my heartbeat I found peace. I found my safety. I found my happy place. For in my heartbeat I found great imagination. I could be anywhere in the world. Of course my knowledge was limited, but in my happy place I didn't seek the riches of the world, nor fame. I sought a world of happiness, peace, and most of all, love.

My happy place was many things. As far back as I can remember, when I was a child, I have always loved animals. I remember going to the library at school and asking for books on animals and butterflies. I couldn't read, so I would stare at the pictures and imagine living with the animals or butterflies I was looking at. Of course, growing up I always had pet friends. I had dogs, cats, rabbits, chickens, birds, etc… Early on in life, I learned that my pet friends were more faithful than humans. My pet friends didn't care what I looked like. They didn't care what kind of clothes I had on. They didn't care that I was poor. They didn't yell at me, or hit me, and they didn't ever judge me. You show just about any animal real love, and they will always be faithful friends and never leave your side. And is why I love drawing animals today. So as a child, as I would listen to my heartbeat, I would soon find myself chasing millions of butterflies, or they would be chasing me under the sun. Or I would be riding on the back of a dolphin, laughing as the water would splash around us, playing and talking in their language.

In my world, I always spoke the language of the animals. Many times when I met nice people in my life, they would be in my heartbeat, feeding wild animals in faraway lands. In my heartbeat I would even have my mother. We would hold hands as we lay down on the grass, counting the birds and butterflies who would stop by to say hi, as they showed us their beautiful colors. Within my heartbeat I was lost in a beautiful world. I

would help my heavy heart to carry on as I drifted to sleep in my heartbeat. I always felt better till I woke up.

As I was growing up, I wouldn't do this very much. I would do it for those I really loved, as my sister, brother, mother, and later my kids. My life had taken on a very wild lifestyle, where I replaced my heartbeat with violence, alcohol, and drugs. Where I believed the escape was better, it came with a price: destruction.

When I landed in a cell in 1993, my heartbeat came back to me, which, by the way, I had pretty much forgotten about. But one night my heart was heavy because the mother of my kids was moving on in life without me, taking along my kids. My family. That night, as my tears fell, my heartbeat came back to me and again, became my comfort zone.

As I sit here on death row, listening to my heartbeat is a major part of my life/world. I do more than escape within my heartbeat. I seek answers there, as well as peace and my sanity, for it's not easy being on death row. But listening to my heartbeat helps. Of course today I still run free with animals within my heartbeat, but now I am the animal. I love seeing myself as a whale swimming the ocean. A lot of times when people decide to walk out of my life because they can't handle my situation, or they need to move on with life, or whatever the reason is, I place them within my heartbeat and relive the bittersweet memories we made, and I thank God I was able to make those memories. I often visit these people in my heartbeat, for they will always be there.

Being on death row means dealing with pain, hurt, madness, suffering, sadness, hopelessness, and depression, and, believe it or not, happiness. So, how do I handle/deal with being on death row? I listen to my heartbeat.

Hi, Mommy!

Hi mommy! Today is a glorious day. God has created me. He sent me from heaven to be with you. Are you happy like I am mommy? Being here today has filled my heart with love! It's a warm wonderful feeling being here with you today mommy! I love you!

Hi mommy! Why are you sad mommy? You should be excited like me! My feet and hands are beginning to grow out! Aren't you happy mommy? It won't be long till I will be able to touch your soft skin and hug you all day long mommy. I love you!

"I TOLD YOU NOT TO COME HERE AGAIN!"

"BUT IT'S YOUR BABY!"

"I DON'T CARE"

"BUT YOU SAID THAT YOU LOVED ME!"

"I WANT NOTHING TO DO WITH YOU OR THAT BABY! ALL I WANTED WAS SEX! NOW LEAVE ME AND NEVER COME BACK!"

Hi mommy! Why were you and dad fighting? Why are you crying mommy? Please don't cry mommy. Look mommy, my feet and hands are almost formed. So I will make you happy mommy, and you don't have to cry anymore. We will be together. I will run and play with you. I will give you butterfly kisses, and we will be happy. Please don't cry, I love you!

Hi mommy! You are up early today. Where are we going today? Look mommy, I can barely wiggle my toe and fingers! I love them mommy! It's a beautiful day mommy. The sun is so wonderful, the birds are singing. It's wonderful. What is this place? Why are you going to sleep mommy? Don't go to sleep.

Let's go back outside. What's going on? What is that? Owww that hurts! MOMMY WAKE UP! OOOWWW!!! HELP ME MOMMY! OOOOWWWWWW WAKE UP MOMMY! HELP ME!! MOMMMYYYYAAAAAAAAAA..........

If you are thinking about having an abortion, please know that it is not the only option you have. Give the child a chance at life. Put the child up for adoption. No matter what you're thinking, there is no good reason, or reason enough, to have an abortion. Please put the child up for adoption. My life wasn't roses, nor easy, but I give thanks to God and my mother for giving me LIFE! Please give the child a chance at life.

Love and Blessings,
Carlos Treviño
2007.

Christopher Wilkins
#999533

A Prose

It is time
My treasure is time
Yes for the loneliness
Torments itself within my soul
The silence breaks relative existence
Hidden somewhere in the stars
The sky already waits
Because to be silent is cowardly
Nevertheless to think forbidden
Only still deep emptiness within me
Manipulative mothers
Backstabbin' brothers
Cold light alone in the dark
You said that it was revenge
No remorse scars my heart
Feel their absolute terror
Harbor unspeakable thoughts
Laugh and dance before me in the rain
They disappear
The furious tears
In the case of storm and sun
Circle darkly over my body
The liberty I can't resist
Six *pep emma* has arrived
Make death my only angel

A Proxy

Terror and power and in God we trust
In spite of ourselves we're diamonds to rust
The snake nurtures death it's life's golden rule
And with every breath you break yourself
Fool
Alive and then dead is a critical truth
Demise understanding
The elect not the youth
No second damned chances or dead men's damned dances
In proxy he's walking on water
Now send in the clowns the six gunman's dawn
Forever call no man father
She'll spoil the rod and spoil the child
He'll beat them for true they're growing up wild
Now sworn into silence
She's being defiled
Forsaken by you his soul is being tripped
Your sitting in judgement as he's being whipped
There is something extra but nothing gained
Our hearts and our minds forever are chained
To tie this all in
There is no such sin
Original
God damned or otherwise
Crux immissa, oi vey it's doomsday you say
Your cross and my soul is the prize
I give and you take lord knows we've heard it before
As it's all been said and this book has been red
In bloodstained writing of yore
It's understood what's done for the good
And righteous benefit of all
To kill a man dead you chop off the head
And surely his body must fall
There's nowhere to hide with our demons inside
It's more blessed to give than receive

Let dogma be damned this life's but a sham
I'd be feeling restrained on reprieve
For love or for money, the root of all evil
Our greed for hope
The lust of all people
Your door into heaven is my window to hell
My cup runneth over, your soul is to sell
A cold-blooded killer, there take him away
An eye for an eye
Least that's what they say
It's never too late yes that's understood
Now go get a rope, it's all for the good
Our big bonfire party is just getting started
This dog and this pony show's dearly departed.

An Essay

The question caught me by surprise and it seems to me that I would be very embarrassed if I has to ask it. Nevertheless, I'll answer it. I have pretty much lost the habit of analyzing myself or anything else, and it will be hard for me to tell what you want to know. I probably did love dear mother, but that doesn't mean anything. At one time or another all normal people have wished their loved ones were dead. My nature is such that my physical needs often get in the way of my feelings.

Anyway, I shouldn't exaggerate. It's easier for me than for others. When I was first imprisoned, the hardest thing was that my thoughts were still those of a free man. For example, I would suddenly have the urge to be on a beach and walk down to the water. As I imagined the sound of the first waves under my feet, my body entering the water and the sense of relief it would give me, all of a sudden I would feel just how closed in I was by the walls of my cell. But that only lasted a few months. Afterwards my own thoughts are those of a prisoner. I want for my daily recreation, which I take in a cage outside my cell. The rest of the time I manage pretty well. I've often thought that if I had to live in the trunk of a dead tree, with nothing to do but look up at the sky flowering overhead, little by little I will get used to it. I would wait for birds to fly by or clouds to mingle, just as here I wait to see my lawyers, ties and just as in another world, I used to wait patiently until evening to hold Kelly's body in my arms. There are others worse off than me. Anyway, after a while a man can get used to anything.

Besides, I usually don't take things so far. The first months were hard. But, in fact, the effort I had to make helped pass the time. For example, I was tormented by my desire for a woman. It's only natural; I am a man. I never can deny that. Sometimes I thought specifically of Kelly. Others about a woman, about women, about all the ones I had

known, about all the circumstances in which I had enjoyed them, that my cell would be filled with their faces and crowded with my desires. In one sense it threw me off balance. But in another it killed time. I had ended up making friends with the head guard, who used to make the rounds with the kitchen hands at mealtime. He's the one who first talked to me about women. He told me it was the first thing the others complained about. I told him it was the same for me and that I thought it was unfair treatment. "But," he said, "that's exactly why you're in prison." "What do you mean that's why?" "Well, yes—freedom. That's why. They've taken away your freedom." I'd never thought about that. I agreed. "It's true," I said "otherwise, what would be the punishment?" "Right. You see how simple it is? You understand these things. The rest of them don't."

There were the cigarettes too. When I entered prison they took away my belt, my shoelaces, my watch, and everything in my pockets, my cigarettes in particular. Once I was in my cell, I asked to have them back. But I was told that I wasn't allowed. The first few days were really rough. That may be the thing that was hardest for me. I would suck on chips of paint that I peeled off the wall. I walked around nauseated all day long. I couldn't understand why they had taken them away when they didn't hurt anybody but me. Later on I realized that that too was part of the punishment. But by then I had gotten used to not smoking, and it wasn't a punishment anymore.

Apart from these annoyances, I'm not too unhappy. Sad isn't it? Once again, the main problem is killing time. But now I know how to remember things, so I don't get bored at all. Sometimes I just think about things. For example, my room. I will start at one corner and circle the room, mentally noting everything there on the way. Every piece of furniture, and on every piece of furniture, every object. And of every object, all the details. And of the details themselves—a flake, a crack, or a chipped edge—the color and the texture. At the same time I try not to lose the thread of my inventory, to make a complete

list. . . . A man who has lived only one day can easily live for a hundred years in prison once he can remember things. And that's just one example. . . . No, there is no way out, and no one can imagine what nights in prison are like. . . .

Well, so I'm going to die. Sooner than other people will obviously. But everybody knows life isn't worth living. Deep down we know perfectly well that it doesn't much matter whether we die at thirty or at seventy, since in either case other men and women will naturally go on living—and for thousands of years. In fact, nothing could be clearer. Whether it is now or twenty years from now, I will still be dying. At this point what disturbs my train of thought is the terrifying leap my heart just took at the idea of having twenty more years of life ahead of me. For this is certainly not living. Besides— imagine what I would be thinking in twenty years when it will all come down to the same thing anyway. Since we are all going to die, it's obvious that when and how don't matter. And those twenty years, or even two hundred years, would not subtract even 20 seconds off the length of the eternity I will be dead.

I've gone round-n-round about it with the clergy—it all seems perfectly normal to me, since I understand very well that people will forget me when I am dead. They won't have anything more to do with me then. The last such encounter, for example—they were concerned about me since I had been sentenced to die by lethal injection. Nothing to be concerned about in my view. It's settled. No stroke or heart disease or prostate cancer or any "natural causes" . . . a lethal injection. That settles it. But this priest, or father, or whatever—not a rabbi—sat down on my bunk and invited me to sit next to him. I refused. All the same, there was something gentle about him.

He sat there for a few seconds, leaning forward, with his elbows on his knees, looking at his hands. He slowly rubbed one against the other. Then he sat there, leaning forward like

that, for so long that for an instant I almost forgot he was there.

But suddenly he raised his head and looked straight at me. "Why have you refused to see me?" he asked. I said that I didn't believe in God. He wanted to know if I was sure, and I said that I didn't see any reason to ask myself that question. It seemed unimportant. He then leaned back against the wall, hands flat on his thighs. Almost as if it wasn't me he was talking to. He remarked that sometimes we think we're sure when in fact we're not. I didn't say anything. He looked at me and asked, "What do you think?" I said it was possible. In any case, I may not have been sure about what really did interest me, but I was absolutely sure about what didn't. And it just so happened that what he was talking about didn't interest me.

He looked away and without moving and asked me if I wasn't talking that way out of extreme despair. I explained to him that I wasn't desperate. I was just afraid, which was only natural. "Then God can help you," he said. "Every man I have known in your position has turned to him." I acknowledged that that was their right. It also meant that they must have had the time for it. As for me, I didn't want anybody's help, and I just didn't have the time to interst myself in what didn't interest me.

At that point he threw up his hands in annoyance. And he started in on me again, addressing me as "my friend." If he was talking to me this way, it wasn't because I was condemned to die. The way he saw it, we were all condemned to die. But I interrupted him by saying that it wasn't the same thing, and besides, it wouldn't be a consolation anyway. "Certainly," he agreed. "But if you don't die today, you'll die tomorrow or the next day. And then the same question will arise. How will you face that terrifying ordeal?" I said I would face it exactly as I was facing it now.

At that he stood up and looked me straight in the eye. It was a game I knew well. I played it alot with friends growing up and usually they were the ones who looked away. The "chaplain" knew the game well too; I could tell right away. His gaze never faltered—and his voice didn't falter either—when he said, "Have you no hope at all? And do you really believe—really live with the thought that when you die, you die, and nothing remains?" "Yes," I said.

Then he lowered his head and sat back down. He told me that he pitied me. He thought it was more than a man could bear. I didn't feel anything except that he was beginning to annoy me. Then I turned away. I leaned my shoulder against the wall. Without really following what he was saying, I heard him start asking me questions again. He was talking in an agitated, urgent voice. I could see he was genuinely upset, so I listened more closely.

He was expressing his certainty that I was carrying the burden of a sin from which I had to free myself. According to him, human justice was nothing and divine justice was everything. I pointed out that it was the former that had condemned me. His response was that it hasn't washed away my sin for all that. I told him I didn't know what sin was. All they had told me was that I was guilty. I was guilty, I was paying for it, and nothing more could be asked of me. At that point he stood up again and the thought occured to me that I could easily break his neck and would if he came to me. He took a step toward me and stopped, as if he didn't dare come any closer. "You're wrong, my son" he said. "More could be asked of you. And it may be asked." "And what's that?" "You could be asked to see." "See what?"

The preacher gazed around my cell and answered in a voice that sounded far away and very weary to me. "Every stone here sweats with suffering, I know that. I have never looked at them without a feeling of anguish. But deep in my heart I know that the most wretched among you have seen a

divine face emerge from their darkness. That is the face you are asked to see."

This perked me up a little. I said I had been looking at the bricks in these walls for months. There wasn't anything or anyone in the world I knew better. Maybe at one time, way back, I had searched for a face in them. But the face I was looking for was as bright as the sun and the flame of desire—and it belonged to Kelly. I had searched for it in vain. Now it was all over. And in any case, I'd never seen anything emerge from any "sweating stones."

The priest looked at me with a kind of sadness. He muttered a few words I didn't catch and abruptly asked if he could embrace me. "No," I said. He turned and walked over to the wall and slowly ran his hand over it. "Do you really love this earth as much as all that?" he murmured. I didn't answer.

He stood there with his back to me for quite a long time. His presence was grating and oppressive. I was just about to tell him to go, to leave me alone, when all of a sudden, turning toward me, he burst out, "No, I refuse to believe you! I know that at one time or another you've wished for another life." I said of course I had. But it didn't mean anything more than wishing to be rich, to have nice things or anything else. It was all the same. But he stopped me and wanted to know how I pictured this other life. That's when I told him I'd had enough. He wanted to talk to me about God again, but I was finished. I told him the truth. I have only a little time left and don't want to waste it on God. He tried to change the subject by asking why I was calling him "man" and not "father." That got me mad, and I told him he wasn't my father; he wasn't even on my side.

"Yes my son," he said, "I am on your side. But you have no way of knowing it because your heart is blind. I shall pray for you." I told him not to waste his prayers on me. He seemed so certain about everything, didn't he? And yet none

of his certainties were worth one hair on a babies behind. He wasn't even sure he was alive, because he was living like a dead man. Whereas it looked as if I was the one who'd come up emptyhanded. But I was sure about me, about everything, surer than he could ever be, sure of my life and sure of the death I had waiting for me. Yes, that was all I had. But at least I had as much of a hold on it as it had on me. I had been right, I was still right; I was always right. I had lived my life one way and I could just as well have lived it another. I had done this and I hadn't done that. I hadn't done this thing but I had done another. And so? It was as if I had waited all this time for this moment and for the first light of this dawn to be vindicated. Nothing. Nothing mattered, and I knew why. So did he. Throughout the whole absurd life I'd lived, a dark wind had been rising toward me from somewhere deep in my future. Across years that were still to come, and as it passed, this wind leveled whatever was offered me at the time. In years no more real than the ones I was living. What did other people's deaths mean or a mother's love matter to me—what did his God or the lives people choose or the fate they think they elect matter to me when we're all elected by the same fate, me and billions of privileged people like him who also called themselves my brothers? Couldn't he see, couldn't he see that? Everybody was privileged. There were only privileged people. The others would all be condemned one day. And he would be condemned too. What would it matter if he was accused of murder and then executed because he didn't cry at his own mother's funeral? I felt that I had been happy and that I was happy again. For everything to be consumated, for me to feel less alone, I had only to wish that there be a large crowd of spectators the day of my execution and that they greet me with cries of hate. Good riddance.

Life is nothing more than trying to get what you don't have yet. If you're homeless and hungry, you want to eat; if your stomach is full, you start thinking about a roof over your head. If you're being abused you crave safety. If you have all that you start thinking of greater things, love maybe. Or being

someone important. A leader or a wiseman. But it's like seeing a beautiful woodland glade on a hot day. It looks cool under the trees and it is completely deserted. However, when you're finally there and in the middle of it all, it's never as beautiful, never as perfect, as it was from a distance. The grass is not greener "over there." And by nature people are just as mean. And petty and ugly, limited line-drawing individuals.

Is the tension between liberty and equality or between indiviuals in society? With each group striving to promote social policies favorable to its own and deter those of others. "Individual Equality" is all illusion. It's false opposition between an individual and society. "Groups" use it against groups, and it's a barrier to our individuality and society. "Groups" use it against groups, and it's a barrier to our individual understanding of what goes on in the world. The behavior of men as individuals is distinctly different from their behavior as members of groups and classes.

The criminal law thus proceeds on the principle that it is morally right to hate criminals. It is highly desirable that criminals should be hated. That the punishments inflicted on them should be contrived as to give expression to that hatred and justify natural sentiment can justify and encourage it. These views are no longer widely shared by criminologists. But it's a double standard. Jailers see it that way, and, admittedly, I do too. And I'm a criminal.

Same cell. Same noises slipping into my head. Different voices with the same conversation. Surrounded by folks that are going nowhere, doing nothing, saying nothing of any deep interest. Talking about the same menial shit that different people in these same cells talked about 10 years ago. In this trap I, too, am caught.

I've said it before. I'm a crook. That's why I'm here in prison. The thing is, I knew what I was doing when I broke the law. I did it intentionally, unlike most of the idiots I have

to put up with in here who never want to admit what they did and are still doing and have always done.

Not that I'm not just as big of an idiot, or even bigger. Because I can see clearly that the law isn't the very glue that holds society together as they would have us believe. And the notion that it is is one of the things wrong with this country. We as a people seem to have lost the notion that in society individual responsibility must always be the foundation for any system of laws and governance. We've been suckered into believing that the solution for all problems lies not with the individual, but with the local, state, or federal government. People think that the way to solve a problem is by passing a new law and spending more money and why not? It's a hell of alot safer for the politicians than facing an issue head-on and having to deal with what is often and unpleasant trust. Things can't be changed. As a society we've gone too far for too long to even go back. It's all easier said than done. Large organizations, agencies, governments, societies, etc., all have to have rules that are applied generally across the board. Individuals, particularly those who are expected to exercise independent judgement, are always faced with having to modify their adherence to those rules, based on changing circumstances. For example, a police officer may stand for law and order as an honest man. But sometimes he may have to go around the law to uphold it. If he didn't "play fair" it was because he feels hamstrung by the laws of the land. Whatever it takes to get the bad guys, do it. There'll be no finer points of law. No splitting of legal hairs. Only instant justice. Devoid of long-winded lawyers, bored or biased jurors. Or black-robed, often corrupt judges. . . . Molest some child and get a bullet in the brain. Rape and kill some elderly person who has spent their life working hard and following the law and get a rope around your neck. Would save alot of money. And save all the excuses. "Mitigation" — "OK, but he had a bad childhood" or "his mother didn't give him enough love" or "the homecoming queen wouldn't give him a second look and he has an inferiority complex" or "cultural rage, the poor kids were just venting

their hostilities towards an uncaring society"—How many times must you have heard all this? I hear it all day. Every day. It makes me sick.

We've all been hurt. Or will be soon. It's a fact of life. And no one can hurt us as deeply as the ones we love. When you allow the others in your life you leave yourself open. Even after years together your affection and trust can be disappointed. Life is dangerously unpredictable. People change. Dramatically and suddenly. Bitterness and resentment quickly replace belonging and affection. The black valley of despair tests every part of your affection. Lose attraction and magic. You sense each others' darkness, falsity, need—very unattractive. Friendship turns. Partners fixate on each other at their points of mutual negativity. We meet at the point of perversity between us. It gives birth to a beast who would devour every shred of affection.

But let's not make excuses shall we? Let's say you've been hurt. A betrayal perhaps. Someone you thought you can trust. Now you've lost the ability to care about most things. Most people. But yourself especially. You're bitter. Everyday is a struggle. You hate yourself without knowing why. You live inside yourself. You can't suddenly change who you are. The thing about it is you're not very good with people. It's not your fault. It's what you've had to do to survive. Everyone you have ever relied on has ended up leaving. It's easier just to never get close. That way you never disappoint, and you never let anyone else down.

You speak of experiencing great physical pain. Migraines, jaw pain, terrible anxiety, palpitating shortness of breath. But I doubt you feel but level sadness or rage. Even still, it's no excuse. "Why" doesn't matter—what's gone is, is it not? Will the "why" change the deed?

Mom—pretty, vibrant. Above all else, kind and gentle. Smiling, laughing. Blowing me kisses. Made me feel special.

Felt heroic around her—mother—turns on me. Gives, then punishes for having. Never could wrap my mind around that dichotomy. Kindness and cruelty from the same person. The perfect mother who loved me completely. The demonic mother who tortured me also. She loved me, and she hated me. She nursed me and cursed me. Caressed and beat. Violence is pure and unrestrained. Like sex. I was entirely vunerable to the mood swings of the woman I depended on for love. When she provided it I felt alive. When she witheld it I felt dead. She was my angel and my devil. Life is strange. It can serve you up the very best things and the very worst things right out of the blue. With no hint at all what is coming. It's no use blaming anyone for anything. Sure, my mom may have made two or three mistakes. Whose mom did not? But did she kill any of those people?

A critical truth is often missed. Self-hatred is the only hatred in the world. It merely finds convenient decoys. Demons lurk inside us. Manipulative mothers and violent fathers. Lecherous mentors and double-crossing friends. Loveless marriages. Dead grandparents, dead siblings, dead children. Death waiting patiently for us. For them. And if in the presence of your own demons and the unspeakable thoughts you harbor, you rejoice. You know in your heart you have found a kindred spirit. One who understands.

My existence is an endless miscarriage. "Justice." That's why juries and judges and the whole rule of law even exist to begin with. They only exist in the first place to buffer the understanding of desire for vengeance. If justice were left to the victims gallows would outnumber jails ten to one. Together a society can aspire to act more like Jesus Christ or Ghandi, but left alone, most will act more like the terminator.

Do you really believe that evil can be locked away behind bars? Don't you understand I'm already inside you?

Perry E. Williams Jr.
999420

My Thoughts on Self-Determination

Self-determination is not something you gain. It's something you use and have to maintain. And throughout all these few years I've been on lock, I have learned that a man can have knowledge and the world at his fingertips, but if he has no morals or self-determination he will only self-destruct. And to me this all starts with trusting in yourself, and to be able to do that and master this, one must have control over his or her thoughts. And that starts by taking yourself in hand and asseverate over all the details of your everyday life. And don't allow your mind, body and soul to do exactly what it wants to do, and administer your command over your mind, body and soul, which allows you to do and starts mastering your own self control and self-determination. Because by mastering the proclaimed title, you can always choose your own path, without awaiting orders from someone else, and you must demand and expect instant action instead of trusting in someone else. So with mastering your own self-determination and trusting in yourself to guide you and protect you in all your ways of life. Because, truthfully, the way to obtaining this is to acquire what I call the trinity of self, which comes through "Productive Progress," because the outer rim of this trinity is negativity, turmoil and choas, and it isn't smart to think outside of this trinity, cause this trinity is self, and you should always approach problems (good or bad) through this trinity of self. And this trinity is a training that goes on physically, mentally and spiritually, and instead of always looking elsewhere for help, look inside of yourself for help; because all you have to do is believe in this trinity of self, which lies within. Now with all that being said, I might by only 24 years old, but I've seen alot about life and can speak from personal experience. Believing in this trinity isn't soft, friendly, or weak, but smart, because, to me, if we showed and acted on this trait the world would be a better place to live. And these are my thoughts on: self-determination!

A Serial Killer in the Form of the Death Penalty

The desire to live is like a thrill, and you do whatever it takes just to live another day; because there are no rules to survival except not being the prey.

The will to keep breathing is holding on till the last second, and you fight til the end, cause death has to be destined.

Never question the reason, because death comes to all like the season; just be sure to stay clear of the path of the devil possing as a man.

Because he's pleasing his soul that's lost and has nowhere to go, while entertaining himself with many murderous shows.

Know that he kills fast, he kills slow, he kills the young and he kills the old, he just kills, kills and kills, in the form of the death penalty.

Closure

It didn't take long to get to my resting place
It wasn't until death row found me
Backed into a dead-end street called "capital murder case."

A case that was the result
Of a pointless desired treasure,
But when a man lost his life
The last thing he felt was pleasure.

I can't justify my actions
And now I face dire ramifications.
I wasn't raised to hurt others
Much less being someone who kills without hesitation.

I'm not by any means an inspiration
And I don't want to be viewed as such by another;
But I pray that others learn from my mistakes
And see that Matthew was a precious son and someone's
brother.

I ask God for healing and closure
For the people I've caused so much pain
And even if I must die for my actions
I hope they can see the sun shining after the rain.

There's hope for better days.
I just pray that love conquers hate.
But know that if you live by the gun
You'll be judged and possibly murdered by the state.

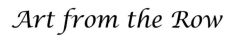

Art from the Row

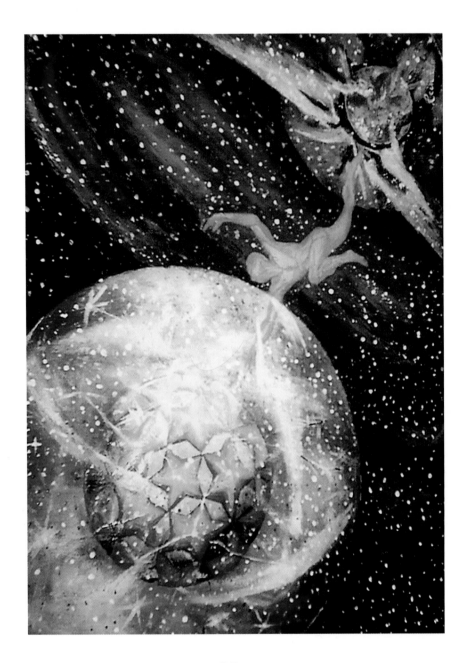

Reinaldo Dennes

Reinaldo Dennes

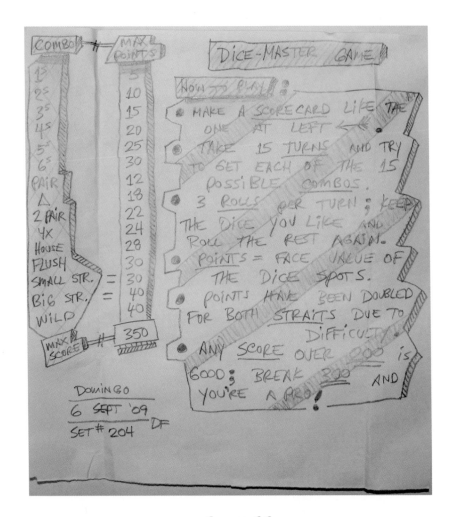

Douglas Feldman

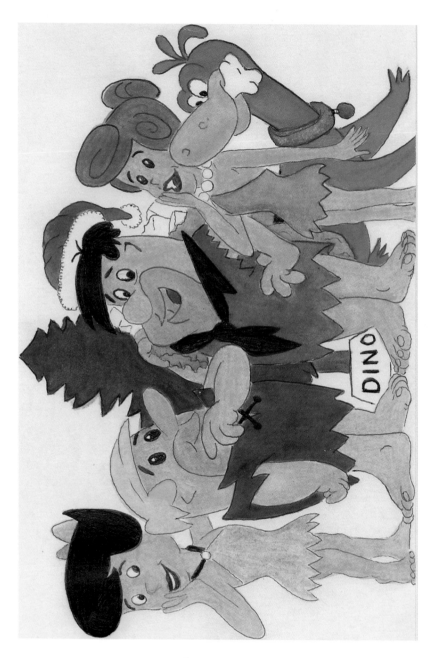

Cleve Foster

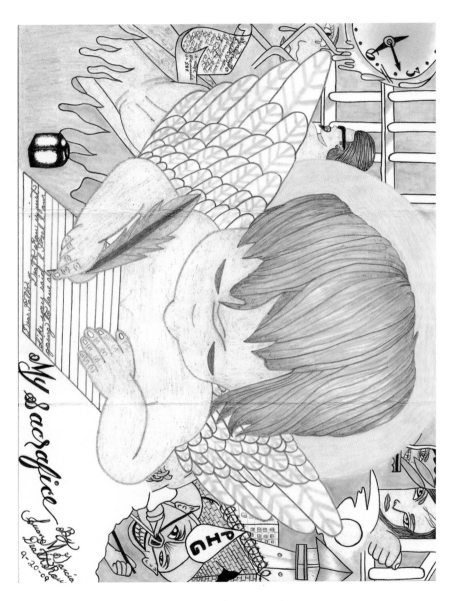

Juan M. Garcia

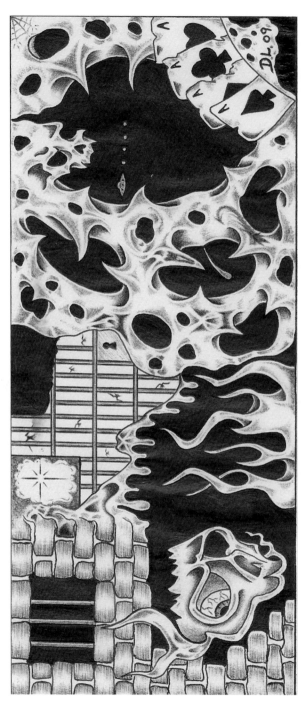

David Lewis

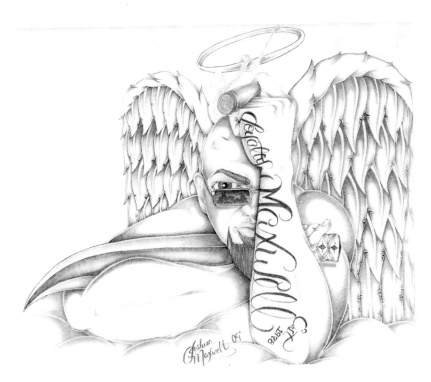

Joshua Maxwell

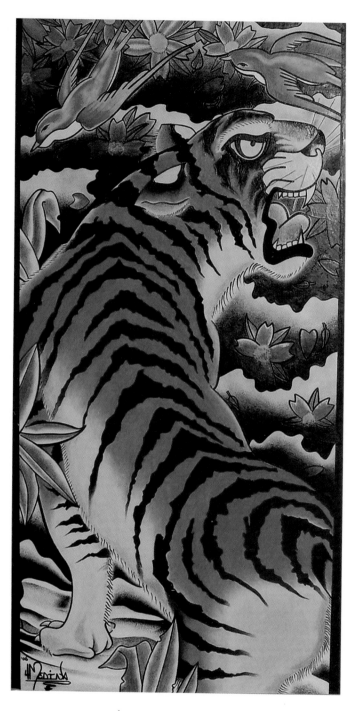

Tony Mesina

Who Am

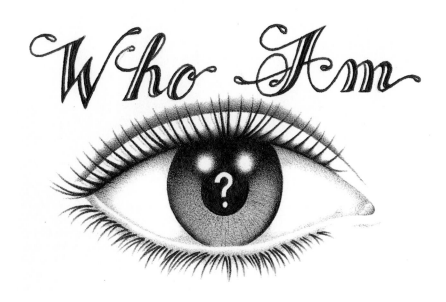

Ronnie Joe Neal

Mark Robertson

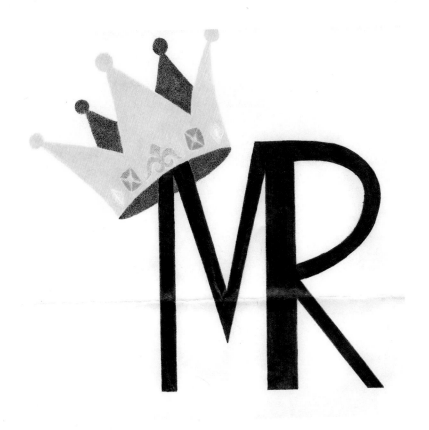

Martin Robles

Carlos Trevino

Carlos Trevino

Carlos Trevino

Comments by the Artists

Doug Feldman, on dice game on 116 and 117:

I would like to participate and I have enclosed a dice game that I make that is similar to Yatzee.

My dice game does not fall neatly into your categories (esssy, art, poetry) but I feel that it is as much artistic as it is a game.

Maybe your students could take a photo of the dice and publish the photo next to the game instructions.

The dice are filled with milk carton recycled from the milk served to us at breakfast.

David Lewis, on painting on 120:

This is what you call true prison art. Back when inmates could write each other you would get an envelope from your buddy that looked like this. It was awesome to get a letter from your friend and the envelope was decked out like this. You would have to be a prisoner to truly understand the meaning of drawing. There is *no* gang stuff and it isn't satanic. When you got an envelope like this from your buddy it was a challenge to outdo him on the return letter. Since we can't write each other anymore and we can't draw on envelopes you don't see this kind of art anymore, only a few still keep it alive and I'm proud to say that I am one of them.

I started with one brick and just let my mind wander. I know that it's no fuzzy dog or pretty flowers but it's still art, real prison art.

Mark Robertson, on painting on 124:

Here's a painting I reproduced. It's my rendition of Van Dongen's "Girl in Forest." I made my paints out of colored pencils

and water and I made paint brushes from my hair since we're not allowed such.

We're not allowed to purchase many art supplies on Death Row. The unit commissary sells a simple set of map-colors and a watercolor set, much like you'd see in a kindergarten classroom. They also sell pens, pencils, illustration boards.

I make my paintbrushes from locks of hair—either my own or a comrade's. I use old pens for makeshift brush-handles. The whole is held together with string which can be scavenged from anything.
I make my own paints by removing the colored "leads" from the map colors, then by soaking them overnight in water and then pulverizing them with a soda can. The end product is like a home-made tempera-paste, which is easily stored when dry. With a little patience, lots of grinding, and some water, I can mix the colors and produce any color I can see. Sometimes I'll add a touch of water-color—between the two any color can be made.

So far my inspiration for painting has come from the many postcards my Swiss friend mails to me. I've painted Van Dongen, Picasso, Cezanne, Van Gogh, etc., over the past few years. My renditions aren't all that great, but with each one I learn something new about technique and increasingly appreciate the mastery of those giants.

As far as poetry goes, most of my inspiration comes from what I think or feel. Life's experiences, particularly a life on Texas Death Row, stirs visceral emotions in me from time to time. I try to stay away from cathartic writing, but when something instinctual emerges in me, I don't try to stop it from expressing itself either.

Reinaldo Dennes, on paintings on 114 and 115:

I started to paint here, for the first time, around 8 yrs ago.

From a one dollar set of 12 colored pencils, I can make hundreds of watercolor paints. No previous experience in either sketching, drawing or painting. Self taught by trial and error. Since these colored pencils are water based they dissolve in water and become a paste which I transfer to small compartments that I also made to hold each color. Inmates are the great improvisers and engineers that from nothing make something, Creationist yes. The brushes are from others' heads since I am bald. From human hairs and the tubes from ink pens, I make fine brushes (the best here). But I misuse them, as rakes, shovels and picks to stir, move the paint to create the magic I do. Mostly I do original work, for its extremely rewarding in both meditation and creation. I think that when I create I am closest to God. Anyone can learn both to duplicate works of art and eventually create your own. My style is unique as I express ideas, visions, truths that I believe today, inspirations and prophetic scenes either of this life or another. Through meditation I tap into the sub-conscious world of creation and ideas. In this classroom I am taught, science, metaphysics, and the divine evolving world we live on. I deeply enjoy the world of spheres, from atoms to the wheels of creation, it seems everything I paint has spheres, wheels and motion. I paint dimensional art as in my mind I can view an idea from any angle. This gift came from perseverance in meditation, praise and worship of the Creator God.

In the past 2 months I have painted 5 original ideas, and today I started on one I call "Love force." I'll explain the idea. Love is a force that when received and filtered through an evolved higher mind becomes live, mercy and compassion towards yourself and others. When received by the lower base selfish mind it rebels to anger, hate, violence. Love and hate are not two opposite forces, but one force filtered as many emotions. The idea started from a song I heard "its a feeling between love and hate." That got me thinking on these emotions, at first I was distracted thinking they were two forces and in all my ideas and visions, eventually any two opposite forms become one in the end. So I started to think about these two as one, and bingo, a flood of ideas. I chose this simple one for it reveals the idea efficiently. The vision is this one house, two stories, two rooms, two windows, one Sun. The Sun shines through each window, behind each window

there is a large gear with four colored filters on each. The upper room has four light colors, the bottom gear four dark colors. There is a water wheel outside—represents trouble, problems of life. The upper room—higher mind, is a scene of joy, an artist painting, a room full of books and light. The bottom room—depression, a man drunk watching T.V. violence. The Sun—the force, how its received reveals the state of mind of the person—the house the mind. The water wheel as it turns, turns both gears and color filters, the events of life can be viewed through the color of mercy or the color of hate, its through which mind do you think from, act from, choose from.
I have around 35 originals all completely different in idea and message.

My heart's desire is to continue to relate these visions to the world, maybe one day with fine oils and horse hair brushes. Prison has provided for me an escape from the world. Through meditation I have returned to oneness.

P.S. The fist starves the hand.

P.S. All my visions come from a drug-free mind.

The Editors

Jennifer Gauntt received her BA in Journalism from Sam Houston State University. She is pursuing her MA in English, which she anticipates receiving in 2011, while working in public relations for the university.

Julia Guthrie received her Bachelors of Business Administration in General Business from Sam Houston State University. After a brief and agonizing career in banking, she returned to school to attain an MA in English. After graduating in May of 2010 she plans on pursue a career that enables her to continue writing creatively.

Trina Kowis has received a BA from SHSU. She will be completing her MEd with a minor in English shortly. Her intentions are to teach the power of language to high school students.

Dave Lewis received his BA in 1973 with a double major in Journalism and English from East Texas State University. A 43-year veteran of the newspaper business, he returned to college to pursue his MA in English at SHSU and plans to teach college English upon graduation.

Shana Templeton received her BA in English from SHSU in 2008. She is currently working on her MA in English at the same school and will graduate in 2010. Her future plans after that are uncertain, but she intends to continue to write creative fiction.

Robert Uren swept chimneys in Houston for over a year before running out of energy and money, at which point he abandoned brushes for books. After earning a Bachelor's degree in English from Henderson State University, Robert entered the Master of Arts program at Sam Houston State University to study literature and creative writing.

Linda Wetzel has a BA in Studio Art and is pursuing an MA in English at SHSU. She currently enjoys working as a free-lance editor and hopes to teach interdisciplinary classes combining the studies of art and literature.